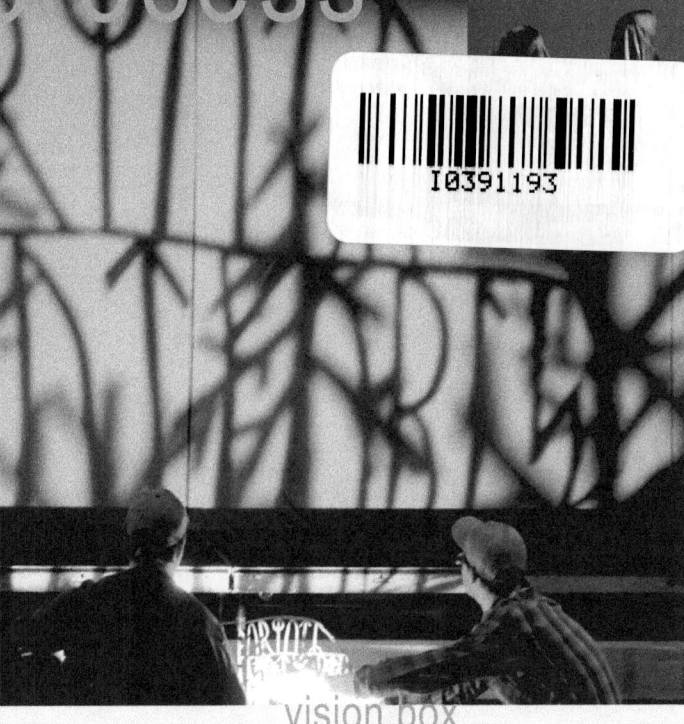

the wild hunt/
the creative process

performance
music
media
puppetry

2

WILD HUNT AND THE CREATIVE PROCESS

vision box
bill pullman
Jennifer McCray Rincon
collaborators/
colleagues/
creation/

for the team

THE WILD HUNT AND THE CREATIVE PROCESS

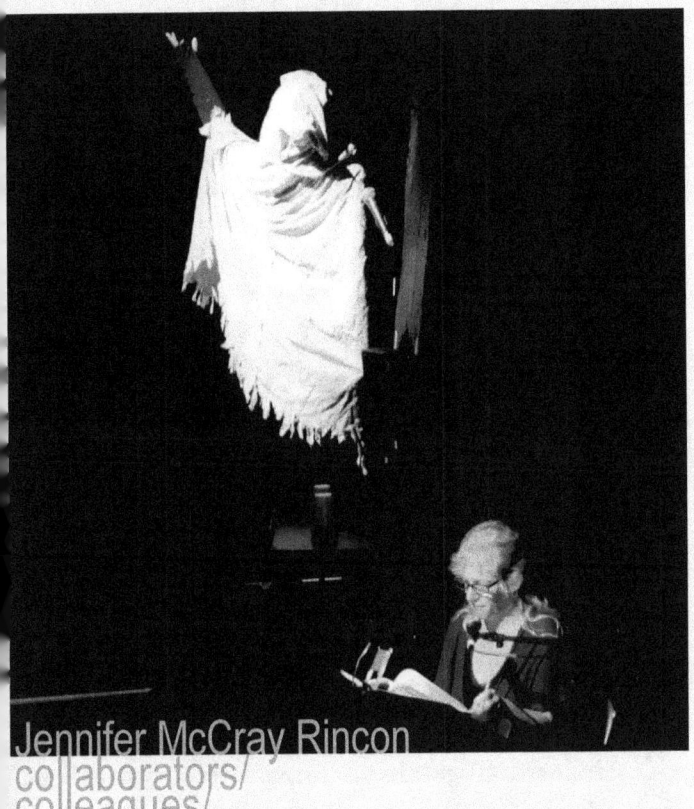

Jennifer McCray Rincon
collaborators/
colleagues/
creation/

THE WILD HUNT AND THE CREATIVE PROCESS

Note from Jennifer McCray Rincon: co-director/coproducer:

I have worked in theatre all my life and always connected with this art form as a way to understand the purpose and meaning of our lives and share this with each other. I have always been attracted to plays and writing that has a strong mythological base underneath whatever story is being told. Whether it is contemporary or from another time or world. And in turn I always believed that stories that have these mythological structures connect us not only to our conscious thought but actually in a powerful way to our unconscious. Joseph Campbell was the great mythologist of our time who believed in a concept he called "mono-myth" the idea that all cultures stories were different versions of one great story,; each story created with different characters and metaphors but with the same intention to guide us through the phases of our lives and to connect us to meaning including a connection to the spiritual in our lives.

I was immediately drawn to Bill's The Wild Hunt as this kind of play; but with something completely new and original. In The Wild Hunt there is a central idea that we have lost our stories and that we desperately need a new mythology to explain the changes in our world. And we do not have this story and we are therefore lost. The central character of Bill's play is a young woman who seems to have some kind of deep understanding and the power of premonition almost a Cassandra like power to foretell a future that she does not understand. And that none else can hear. "We've lost the thread of the story...but when we lose the story....then we've lost the power to soothe the crisis" Bill's play captures a feeling, a time, a condition we are living in of disconnection and fear. Perhaps we have lost the basic understanding of the meaning of our lives and ignored to find that again we need to find new myths to explain our new world. The Wild Hunt for me is an attempt to reconnect us to each other, to the world in crisis and perhaps most importantly to ourselves.

the wild hunt/
the creative process

performance
music
media
puppetry
WILD HUNT AND THE CREATIVE PROCESS

vision box
bill pullman
collaborators/
colleagues/
creation/

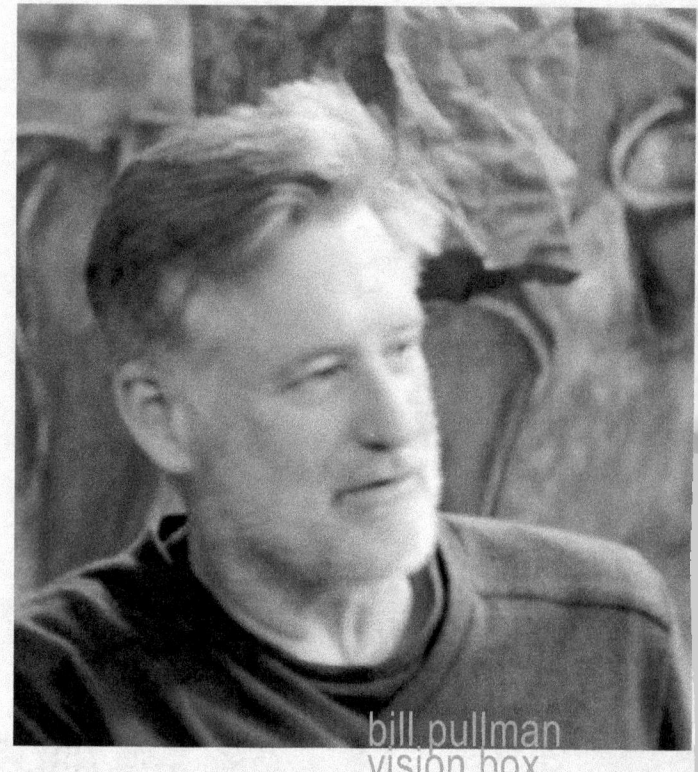

bill pullman
vision box
collaborators/
colleagues/
creation/

THE WILD HUNT AND THE CREATIVE PROCESS

The Wild Hunt – Phase Three Workshop V11-30-16

This workshop, produced in association with The I&G Fries Foundation, Visionbox Studio and Hartsville Productions, will allow the creative team to have a concentrated time of three days to collaborate on the details of the last section of the piece. Then we will work with the nine actors, a reader, and three puppet-technicians over two five-hour sessions. The second session will culminate in an in-house read-through of the script. The puppet team will work away during the week and offer some new tests and drawings for the read-through. Philip and Tamara will join for the two sessions-with-actors and will offer schemes of the Media potential (Philip) and Movement (Tamara).

Schedule:
Jan 2 / Mon - Creative Team TRAVELS to CO, they ?join Gary for dinner
Jan 3 / Tues – Development session/Skylight Station 11am until 5pm
Jan 4 / Wed - Development session/Skylight Station 11am until 5pm
Jan 5 / Thu - Development session/Skylight Station 11am until 5pm
Jan 6 / Fri – First session with Actors/ Skylight Station 9am until 3pm
Jan 7 / Sat – Second session with Actors/ rehearse: 11am-2:30 Read 3-5pm.
 Debrief over dinner.
Jan 8 / Sun – TRAVEL back to LA

Creative Team: Bill P, Jen R, Gary G, Maesa P, Jason H, Jack P, Tamara P, Philip B
Actors: Maesa P, Mark R, Tim, Laura Jo, Nicole, Viktoria (Oliver), Isabelle, Eloise, Jaryd Smart (Robert)
Puppet-techs: Jack, Nick, Charles
Assistants: Andrew, Reader:

THE WILD HUNT AND THE CREATIVE PROCESS

The Wild Hunt is a winter solstice story with elves and magic but no jolly Santa Claus... It is a performance piece that uses music, text, puppetry and movement to investigate a young girl's journey to triumph over the imminent darkest day of the year – she has to survive her internal wars as well as her premonitions of Earth's impending catastrophe... Beginning at her Health Care facility, she eventually transitions into a mysterious, alter-world framed by ancient Yuletide mythology with the hope of rescuing her lost brother and preventing a dark implosion of humankind.

The Wild Hunt

Written & Directed by Bill Pullman

One Night Only Event! Special Work-In-Progress Showing

January 10th, 2016
7:00pm
EXDO Event Center
1399 35th St, Denver, CO 80205

For Reservations and More Information Visit:
www.visionbox.org
Call: 303.573.4940
Email:
info@visionbox.org

Presented By Visionbox Studio and The I&G Fries Foundation

Jennifer McCray Rincon,
Founding Artistic Director
Denver Academy of Dramatic Arts
at Visionbox Studio

Visionbox

VISION BOX.

THE WILD HUNT AND THE CREATIVE PROCESS

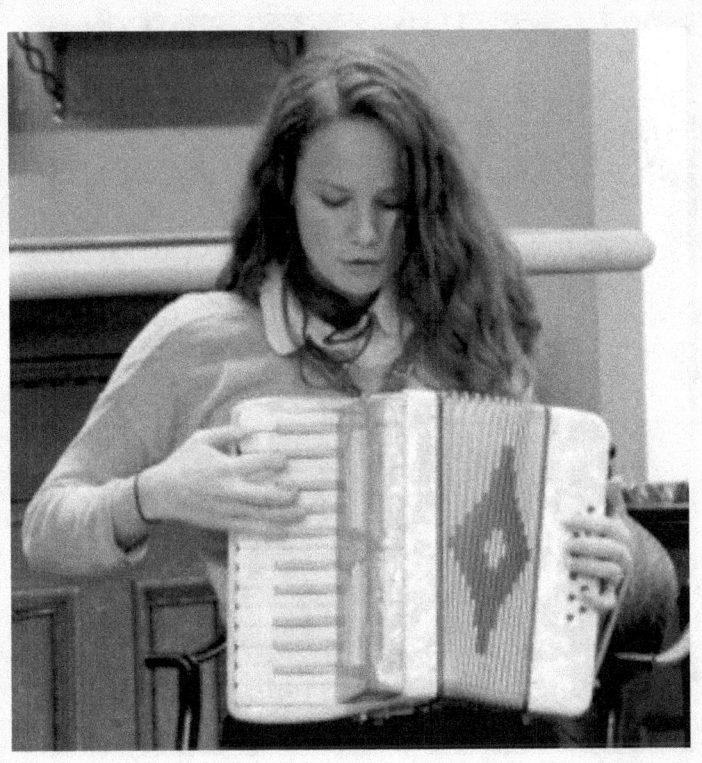

THE WILD HUNT AND THE CREATIVE PROCESS

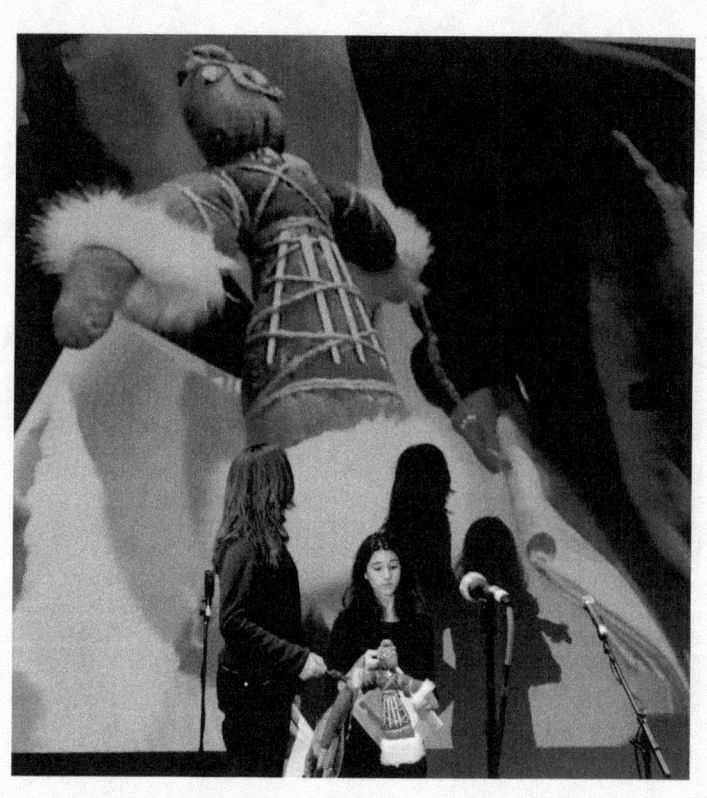

THE WILD HUNT AND THE CREATIVE PROCESS

THE WILD HUNT AND THE CREATIVE PROCESS

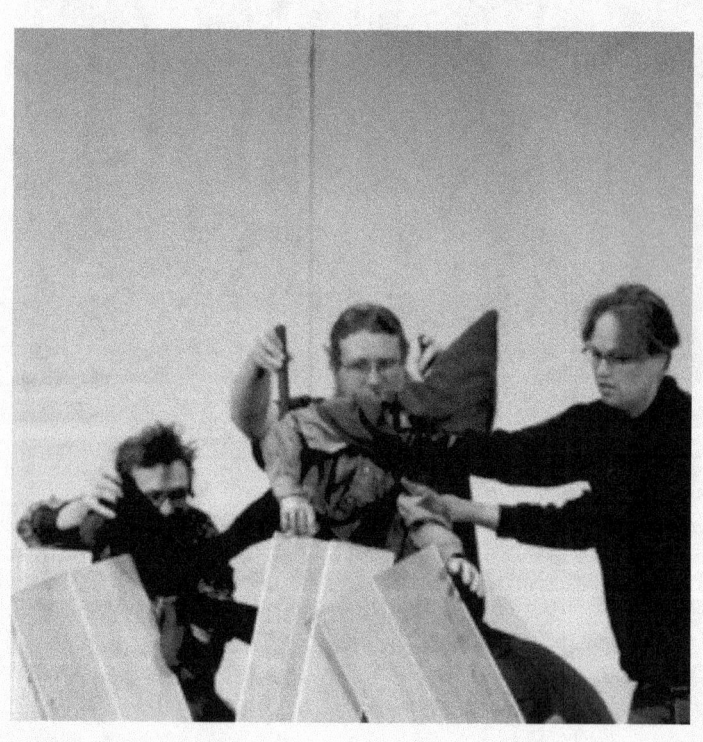

THE WILD HUNT AND THE CREATIVE PROCESS

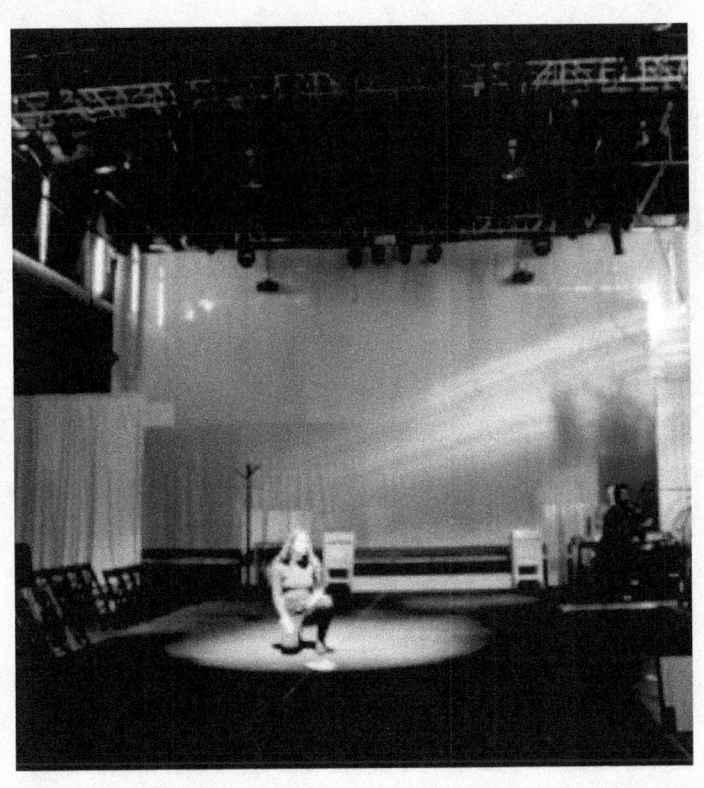

THE WILD HUNT AND THE CREATIVE PROCESS

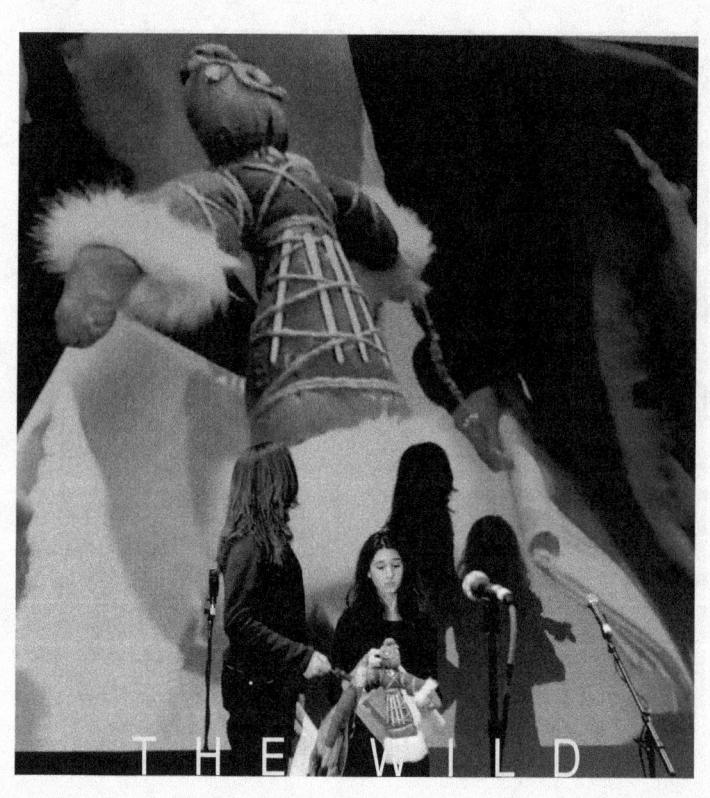

THE WILD HUNT

THE WILD HUNT AND THE CREATIVE PROCESS

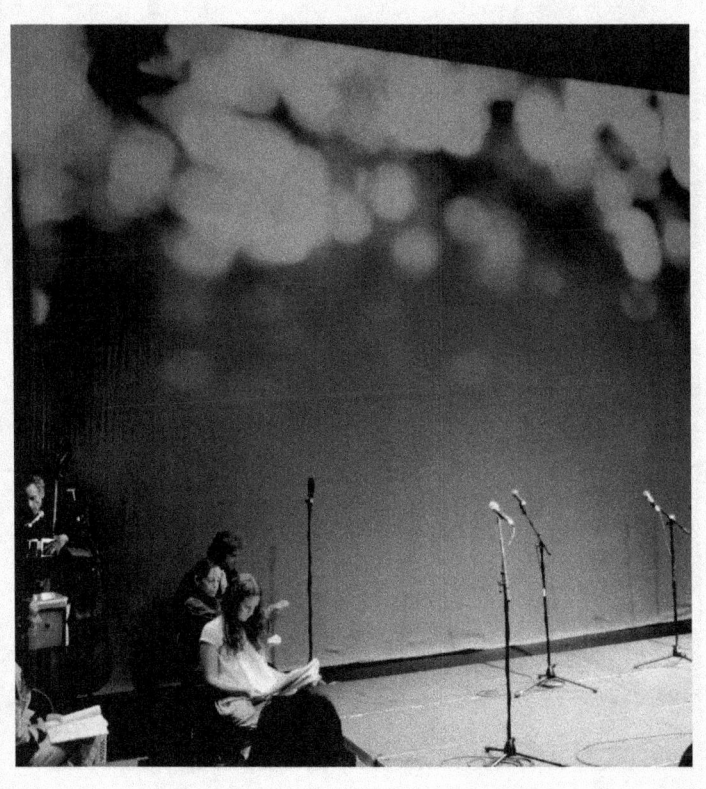

THE WILD HUNT AND THE CREATIVE PROCESS

The Wild Hunt _____

A Play With Songs By B Pullman

The Wild Hunt is a winter solstice story with elves and magic but no jolly Santa Claus...

It is a performance piece that uses music, text, projections, puppetry and movement to investigate a young girl's journey to triumph over the imminent darkest day of the year – for her and possibly for us all.

She has to survive her internal wars as well as her premonitions of Earth's impending catastrophe... Beginning at her Health Care facility, we eventually transition into a mysterious, alter-world framed by ancient Yuletide mythology with the promise of rescuing her lost brother and preventing a dark implosion

of humankind.

Produced by Hartsville Productions, Visionbox Studio, and The I&G Fries Foundation

v.11-14-2016

ii. CAST OF CHARACTERS

LUSSI, 20's, a girl accused of being dissociative, but could rescue us from the darkest times. ROBERT, 20's, a patient grown weary and at times, a spectral shape-shifter. CLEMMET, 50's, a counselor. And later, a Draugr (don't ask). MADELYN, 30-50's, the Director of the Facility, believes in the rational.

IZZIE, teen's, a patient never separated from her close associate, Abby. ABBY, teen's, a patient bonded to her 'sister' Izzie but more social than her. SAMANTHA, 20-30'S, a patient who has a need to be respected, and has her ways. OLIVER, 30-50's, a staff member with creative-destructive instincts, all-seeing. YULIN, 20-50's, a staff member who hides much of his interior life from the world.

NOTE: Each actor exists in the world of the Health Facility, and in the Astral World of the Wild Hunt. PRODUCTION NOTES

The time and place shift between the Facility and the Astral World. In both worlds, the actors are most often specific characters with names, and at times they appear as vaguely-identified beings leaching through their established selves.

THE WILD HUNT AND THE CREATIVE PROCESS

Production elements consist of puppets of many modalities, masks, and environments created with projections and props.

SONGS and UNDERSCORES

PRE-SHOW THEME p1 *FUGUE TANNENBAUM* p2 *DON'T FORGET THE TIMES/* FirstVariation p5 UNDERSCORE: THE WILD HUNT/ Wind and Chaos/ Short Variation p6 UNDERSCORE: THE WILD HUNT/ Second Variation p8 *DON'TFORGETTHETIMES/*Full p9 UNDERSCORE: DEEP TANTRUM p11 *ODIN'S THEME/* First Occurance p11 UNDERSCORE: ASTRAL HOVERING(catch)/ HUNT/ Mixup p13 *ODIN'S THEME/* First Variation p14 UNDERSCORE:DOLLDREAD p16 *WHAT IS IT? HOW IS IT?* p18 *DON'T FORGET THE TIMES / REPRISE* p22 *I DONT FEEL QUITE MYSELF TODAY* p25 UNDERSCORE:ASTRALHOVERING p28 *LITTLE DO THEY KNOW* p29 ODIN'S THEME / Second Occurance p33 UNDERSCORE: WIND AND STORM p34 *IYN WARDZBACK* p34 UNDERSCORE: THE WILD HUNT/ Wind and Chaos/ longer variation p37 *BROTHER AND A SISTER* p41 *THE LONELY TRAVELER* p43 UNDERSCORE:THETREEOFTHENINEWORLDS p44 *DON'T FORGET THE TMES/* PROTECTION VARIATION p45 *ODIN'S THEME/* REPRISE: They Are Coming For You p45 UNDERSCORE: ASTRAL HOVERING/ LOKI SEES ROBERT p46 UNDERSCORE: DOLL DREAD/ REPRISE p47 *GATHER'ROUND* p48 *GATHER ROUND/VARIATION*: Dolls Spin p50 UNDERSCORE: ASTRAL HOVERING/ Loki Sees Lussi p50

Addendum: (*Unfinished) *THERECKONING/*LokiVariation p53 UNDERSCORE: ASTRAL HOVERING/catch **UNLEASHED*/rain **I GREET THE DAY*/toubala *UNDERSCORE: MORNING/ Morning Field *UNDERSCORE: HIDING/hiding It **STILL YOU'RE WITH ME*/hope *THE RECKONING/ FULL* P61 **INTO THE STORM*/chant to drone *FUGUE TANNENBAUM*

iii.

THE WILD HUNT

*A SOUND of wind at the crescendo of the Music. A SLAM is heard. (Music out). * It is followed by TAPS as if maybe a wooden shutter has blown open. The tapping builds until - - TWO LOUD SLAMS, and then more tapping -- THREE SLAMS giving over to A CHAOS OF **

TAPPING as Figures move onto the stage.

THE WILD HUNT AND THE CREATIVE PROCESS

YULIN Here it comes. The storm. This is insane.

CLEMMET * Yeah it is. It's insane. *

ABBY AND IZZIE (*Abby's words in* straight font, *Izzie's are in italics. Unison speaking is underlined.*) We need somebody, *come on*. They aren't latched, come on up here, *in here*, nobody closed the shutters.

YULIN Close them, we've got to close them. It's really - it's blowing in.

FUGUE TANNENBAUM: * OLIVER *

PRESHOW THEME

A short figure, OLIVER, walks into the space, humming Tannenbaum quietly.

OLIVER O TAN EN BAHM, O DAH DAH DUM,

WHAT IS IT DAH DA DAH DAH (CONT'D)

ABBY AND IZZIE They are still open. It is going to blow everything apart.

* *

* * *

This one's going to last. It's big.

CLEMMET

7-14-16

TALKING over the WIND and the SLAMMING.

YULIN I think with all this noise... we're going to be on edge for a while.

CLEMMET We knew it was ... It's a winter storm from the North. Bad one.

YULIN It isn't the end of the world. Not yet anyway.

The wind, banging shutters, voices LOWER IN VOLUME, which begins to allow Oliver's singing to be heard more. Other voices join in.

ALL O TAN EN BAHM, O DAH DAH DUM, (CONT'D)

A lone figure appears in a separate light. LUSSI.

She crosses across the back and comes forward, preoccupied with a two-feet-tall representation of a tree she carries that has small lights on it. But she is also aware of the storm outside. As if she is listening for some sound inside the sounds.

O TAN EN BAHM, O DAH DAH DUM, (CONT'D)

Three figures (MADELYN, SAMANTHA, and ROBERT) stay just outside Lussi's pool of light.

MADELYN MADELYN, SAMANTHA, ROBERT

So.... Lussi.

2.

7-14-16

Lussi.

ROBERT *(wants a private conversation)*

SAMANTHA

(casually chatting. Madelyn and Sam don't hear when Robert speaks)

Isn't this just the best time of year? My favorite holiday. Are you excited? Lussi? There is so much happiness. Good food. Everybody gets together. People say hello on the street. It gets darker now but then with the lights... Cozy. Right?

FUGUE TAN: OLIVER IS JOINED BY C, I, A, Y

MADELYN Oh yeah! Everybody has their different things they like to do. Different traditions. To

celebrate. Didn't your family do special things, Lussi? SAM

We did. Oh, yeah.

MADELYN We always have silly things we like to do, and different decorations.

These big plastic reindeer.

SAMANTHA ROBERT

Lussi. Are you buying this? *(Laughing)* It's so sad.

MADELYN I love those reindeer. No matter where you are in the world, it's this fake wintertime, you

know? We had huge garlands of fake green pine boughs, you know? But at night, with lights in them, they looked pretty good.

SAMANTHA Daytime, really not so good. And didn't you always want the big storm to come? Make

everything magical.

ROBERT Lussi. . . This celebrating. Celebrating what?

MADELYN They may be silly things we do, but they are rituals that bring great comfort.

*

7-14-16

3.

4. People make a big deal of the holiday so they can convince themselves that they have

ROBERT nothing to be afraid of. *(off Lussi)* Hey, it's true.

A magical time of year.

ROBERT Really. It's just a chance to buy more stuff. And try to feel better.

SAMANTHA

SAMANTHA We had this big Santa cake tin. Made a big cake, and put red frosting all over him, and

these little licorice gum drops. I guess that was his belt. I liked to eat the belt, before anybody else got to it.

END: FUGUE TAN

ROBERT

(agitated, searching for better words)

PLEASE, give me a break. Why are the holidays so lonely for so many people? Because all that "cheer" kind of drives ya crazy, right? Buying all those presents? It's insane. People. *(He starts to leave)* You and me, we'll stick together. *(Just before he exits)* Right? *

Lussi doesn't answer and puts more attention on the tree she is carrying.

Madelyn moves closer and sits close to Lussi. Sam eventually joins them.

MADELYN I know this can be a hard time for some. But the darkness is what outlines the light. Like

the winter is needed so we can have spring. We need Old Man Winter. Oliver starts singing an open-throated note.

DON'T FORGET THE TMES/ VARIATION

FUGUE TAN: OLIVER SOLO

AGAIN

7-14-16

Others (C,I,A,Y) eventually join in chords. The sounds of the wind and tapping fades.

MADELYN My father used to call him OLD MAN WINTER. He would never say Santa, he would

say Old Man Winter. From the really old days. Old pagan times - guys would put on some fur and a beard and go from home to home and ask for food and hospitality.

SAM Yeah. Santa kind of still does that - asking for some cookies to be put out for him on the *

big night. But...poor guy, I don't think anybody is really putting out for him anymore. * OLIVER

DON'T FORGET THE TIMES (CONT'D) *

MADELYN Yuletide. The people in the homes, they would be giving out food and small things, and

by giving out stuff, it would bring them luck. And protection.

SAMANTHA Right, right. You kind of want to be generous. I guess that's the point of it all.

MADELYN And Lussi, you'll like this. In the really old days, the lights - they were candles I suppose - *

they were put on a tree. But the tree wasn't just a tree, it was -- see, none of this was * written down at the time, it lives in stories--

So what was it?

SAM

MADELYN In some places, the tree was to remind everybody. Because for them, the tree was the after-

world. This was the place the ancestors lived. SAM

Weird.

ALL OH, DON'T FORGET THE TIMES...

DEAD SOULS SEEKING .. LIVE SOULS HIDING...

Clemmet, Izzie, Abby, Yulin join in with Oliver.

7-14-16

5.

MADELYN Amazing, isn't it. The after-world was a kind of unfathomable tree. A tree where the spirits *

lived. Amazing.

SAM Or it's just weird. *(beat)* Have you heard this stuff before Lussi? Because you don't look

surprised.

Lussi stands, and then picks up the tree. She begins * to cross away, but still listening to Madelyn. *

MADELYN They believed that there's a world just on the other side of a thin membrane separating us from it. At this time of the year, the winter solstice, that's when this membrane was most

permeable.

Lussi stops, looks back at Madelyn and then * continues on. *

MADELYN That's part of the story anyway. And the lights on that tree, they were there to keep the *

spirits from coming back and taking over. * *Again, Lussi stops to consider, but then forges* *

THE WILD HUNT AND THE CREATIVE PROCESS

on. She carries her small tree to Oliver. * SAM

It's like a colorful story, I guess. From the old days. Wouldn't hold up in a court of law.

Oliver places the tree in a niche so it remains in sight. Lussi watches and then as she turns away, * *Oliver speaks, referring to the tree.*

OLIVER And Lussi, you know this. The tree is where the spirits live. *

Lussi turns back. Oliver isn't who he seems to be.

The light SHIFTS SUDDENLY to reveal a more defined space. A health facility maybe.

6.

7-14-16

A BURST of enthusiastic cheers, as if someone has just said: 'let's hear it for Lussi'.

OTHERS Welcome!! So good to have you here. Yay. Yay for the new girl, ETC

CLEMMET

(As the burst dies down, in a one-on-one tone)

We like to think we are your family for now.

YULIN We have a lot of traditions here too. At the holiday. We do little things that make it feel

*

like home.

It's a great facility.

CLEMMET

OLIVER We like to think of it as a Spa for the Soul.

ABBY AND IZZIE *(Izzie/italics, Abby/straight font,*

unison/underlined) We heard about things that they've done here. *You know*, other years here.

ROBERT

(Entering)

Ooo, yeah. Those wonderful pageants about mythical worlds.
CLEMMET

Robert. See who's here? Look, it's Robert! Hey. Since you were coming, Lussi, I had to get here before you did.

7.

Hey. *(They hug.) All the decorations,* these little figures, little set-ups.

SAM ROBERT LUSSI

ABBY AND IZZIE

7-14-16

ROBERT Please. *(He moves away from the twins)*

ABBY AND IZZIE *Not weird religious stuff.* Cozy. You'll like it.

The group CHEERS again in enthusiasm. MADELYN

This is where we come to be sorted out! This is where we come for our reckoning! ABBY AND IZZIE

Oh. Hey.

Hey. Robert. Not so bleak. Yeah... Yeah...

IZZIE ALL

The group becomes quieter. CLEMMET

The group turns away from Robert and Lussi. They hold in place as LIGHTS SHIFT to a spot on Lussi and Robert.

Lussin moves to him. Her look commands his attention.

LUSSI You're my brother. Ever since I met you. You and I are one. *(shift in tone)* Don't ever

leave me.

7-14-16

8.

Don'tworry. You'lllikeit. You will.

CLEMMET

ROBERT

(false enthusiasm)

I need you.

(Robert steps back.)

The others turn and disappear as the LIGHT CHANGES. Robert and Lussi become alone.

ROBERT I don't think you know this but here's some really old knowledge. About a Yuletide

phenomenon. About The Hunt, do you know about that?

ROBERT (CONT) And at some point, a strange silence would be noticed by some. A storm coming. Some

would hear dogs barking for no reason. And then the winds would blow. The skies will open, and down through would come this spectral hunting party. The Wild Hunt. Non- living beings. Hunting for the lost souls. The souls who are not fully living. And they will become forever part of the Unforgiven.

LUSSI NO. It won't happen. You'll be forgiven.

They will be hunting for me. I know how to prevent it.

ROBERT

LUSSI

ROBERT Maybe I'm looking forward to it... *(then he breaks the quiet)* HEY. Just kidding. I'll be

alright. No. I know what to do. I'll protect you.

LUSSI

He crosses out. Suddenly the sound and lights collapse.

A lone figure, LUSSI, walks to stand in a shaft of light. She goes to her knees and begins her 'protection' rituals.

MUSIC: DON'T FORGET THE TIMES

THE HUNT/ VARIATION

7-14-16

9.

OHHHHHHHHHH

L/ I / A/ R / C

*The group continues 'OH's as single lines are *

*spoken. * OLIVER- HUSH NOW TO HEAR CRY... * YULIN- YULE DAYS COME TO TRY... * ABBY - THE WINTER MAKES COLD... * MADELYN- REMEMBER THE OLD... * IZZIE- OH, DON'T FORGET THE TIMES... * ALL- OHHHHHHHHHHHH *

LUSSI continues her rituals, while SPEAKING * TEH WORDS in echo to the CHORUS' SINGING * of the second verse. *

LUSSI * LAND OF IN-BETWEEN... *

ODIN'S WORLD AND THE SEEN... DEAD SOULS SEEKING .. LIVE SOULS HIDING... OH, DON'T FORGET THE TIMES... OH, DON'T FORGET THE TIMES... *

ALL OTHERS * OH, DON'T FORGET THE TIMES... *

There is a chaos of screeching birds. LIGHTS shift * to the early morning dark. LUSSI walks along the perimeter, speaking in her Alter- voice. It is a lament with a low-boil urgency. During this, * CHARACTERS from the Facility cross through,

interacting but we don't hear what they are saying. They don't notice Lussi.

UNDERSCORE: DEEP TANTRUM

LUSSI The Winter Solstice. I seem to know and I wish I didn't know that the winter solstice will

be a time when the days can be dark as closets, storms rage, and no matter how bright the banks of light inside, the world could be locked in a box and maybe never see the light of a full day again. *(Pause)* Weather. It will be different. And it will begin at that dark time of the winter.

10.

A Dark Night to come after all burning days, [MUSIC] a deep tantrum of storms and forms of blasting winds. That is when the wasting flesh of the dead comes to take the half- living. Whoa. Yeah, whoa. This is the dream I keep having. (*Pause.*) Like in a fever.

Most everyone will tell you that's not possible, who wants to think that it is possible we won't be able to do the things we're doing today. We think the blanket will always be this warm, roof-tin always this tight, and food -- with food now, if you can't possibly stand it you chose something else. It's not a matter, right now, of what you can't have. It's not a matter of it is no longer available. Even when you are in some kind of institution. *

LUSSI (CONT) But soon maybe... it will be. Maybe we won't even have the opportunity to make a waste

of it. And on top of that there will come a long dark night, a tantrum of a storm, and the unforgiven part of us will come to take the half-living. Those not wanting to be awake. That's my dream. (*Pause*) I don't accept it. At least not yet anyway. None of us really do.

I wish I weren't as I am. I'm of a different sort. That's what I'm being told I am. Maybe that's always the situation when you have had bad things happen that involves somebody you love deeply.

Robert has entered ROBERT

Lussi. You remember don't you? * LUSSI

Remember what? This! (*He brings out cups for the cup game*) Yay! Why? What did you think I was going *

ROBERT to say? Come on, let's see if you remember how to do it.

Lussi joins the cup game. She continues to talk to us but is also watching Robert, as if sensing a change in him. Robert is focused on the game.

In the reading version of the play: Abby takes Lussi's script and assumes her 'voice' as does Izzie, eventually.

11.

LUSSI (SPOKEN BY ABBY & IZZY) * I can see the dark days. I can see all the ways that we don't have the right knowledge. The * right knowledge to gaze into the face of what we don't want to see. Or that there was once *

I love your hope. Really I do.

ROBERT

(as their hands touch palm to palm, they hold them there)

LUSSI / SPOKEN BY ABBY & IZZY The wisest man we have - the Hawk-man, Stephen Hawkening - who is crippled disease and speaks through a machine - says that soon we will have no choice but live in the stars. Right, live in the stars. Because we can't stop being who we are

Lussi and Robert freeze - their open-palmed hands touching.

LUSSI Because we can't stop being who we are.

Robert hears her tacit meaning. He abruptly ends the game and crosses to look out a window

ROBERT Listen. It's that quiet-berfore-the-storm.

LUSSI stares into him for his avoidance and attitude. LUSSI

(dismissive of him and his deflection)

Oh, okay. Weather-talk.

She crosses to get some distance so she can speak to

him. The weather talk , "These are strange times, aren't they? Isn't it strange weather?

with a to go

12.

old knowledge, if we can only remove the blinders, old, old knowledge that is hidden

somewhere in the right-sided room of our brain-house. We lost access to it along That knowing which could let us see the unseen. And be surprised by what we've *(Pause.)*

the way. ignored.

now. *

Conversations when somebody says, hey, don't worry, a really smart person will eventually figure these catastrophes out, because there will be money in it. Right? Ha. Ha."

ROBERT Yeah, Ha, Ha. *(Turns to go)* I can't stand it. *(crosses and sits)* *

DEEP TANTRUM: OUT

LUSSI Something is wrong. *(all stand)* And for one second it is dead silent. The room actually *

heard something inside what was said. The dark thoughts enter. *(The OTHERS move to * positions hear the platform.)* *

Clemmet and Samantha have stopped their mute conversation. As if they are listening to something, something serious.

LUSSI (CONT) * Eyes lowered, clearing of throat, a moat in your eye, an itch in your ear. *(The OTHERS * lower down and eventually retrieve a mask from under the platform)* And then I can hear a *

sound.

UNDERSCORE: ODIN'S HERE *

(A shifting tone.) It is only one second. In the one second, I hear a chime, and I hear the world open. And then... that second expands.

(the shifting tone is heard again) *

The sound of time stretching... *(Again, the tone of two notes)* Then I see them. *(The * OTHERS stand with one hand pressing A HALF-MASK to their faces)* I see the half- * formed figures. The creatures coming from the darkest coldest North of existence. * Shapeshifters in many forms.

(OTHER FIGURES (O,Y,C,M,S,R) have joined the choral tone.)

LUSSI I see it now as I saw it and heard it back when we lived long ago.

Odin.

THE TWINS (IZZIE/*Italics*, ABBY/straight font,

unison/underlined)

13.

LUSSI THE TWINS LUSSI

Old-en. Olden times... Odin, a god. Shape-shifting times. Dead souls seeking, live souls hiding.

THE TWINS Odin, *you'll find, Odin, in the tree of the,* Nine Worlds, and the leaves of the, Eight legs, the

THE WILD HUNT AND THE CREATIVE PROCESS

beasts of the, Austergard. *He will take your brother.* The part of your brother you love. *Your brother, Robert*, will go to live in the Nine Worlds of Yggdrasil. *(They slowly exit.)*

END: ODIN'S HERE

LUSSI They begin to fade. Shimmering wisps of Creatures, beasts, figures fade. (*The OTHERS* *

twist away and down to put their masks away) Yet still, out there in the ether they are * waiting. Squint. You might just see them. They are all waiting. For you to hear the words * and their power. And - then - they are gone. (*The OTHERS cross and sit.*) *

THE TWINS (OFF) Dead souls seeking. Live souls hiding. Your brother. He will be with the dead.

SHORT: ASTRAL HOVERING/ HUNT MIXUP

Lussi starts to cross toward Robert. * LUSSI *

They will try to take you. *

MADELYN * (carrying her coat, Madelyn moves to * catch Lussi's arm) * Lussi... *

LUSSI * (urgently, trying to move to Robert) * The Wild Hunt will come. I am ready. Down they come. The shards of beings riding * shards of steeds. * (*Some spoken to Madelyn, the rest towards where Robert is*) He wants to be gone. *

14.

7-14-16

15. Gone with the Hunt. GONE with those shapeshifters. GONE so I can't find him. NO, I *

WON'T LET YOU GO-- NO! * SLAM/END: ASTRAL

--Lussi?

What is it?

HOVERING

MADELYN spins Lussi around to confront her. * Yulin comes in just behind her.

THE WILD HUNT AND THE CREATIVE PROCESS

MADELYN

LUSSI

(She is now almost a different person. Lost.)

I'm sorry. You aren't sleeping well, are you.

MADELYN

(Hands her coat to Yulin who hangs her jacket on a coat rack. This, a small rolling table/bed and nine folding chairs represent "the Facility")

How is it going? Were you up all night?

LUSSI It was... I need to be awake... Right now.

MADELYN You were doing so well. With the anxiety. You have been free from it for quite a while,

right? (Pause.) We got the meds working better, didn't we? And you liked that new * bracelet that Robert gave you. *

LUSSI I didn't need it. I can't remember. Who gave it to me?

MADELYN

Robert.

LUSSI Robert. They are calling to him. From the coldest North of Existence. The black ravens

fly across the sky. I heard it.

7-14-16

Hey, Wild-child.

The counselor CLEMMET in a staff coat, enters. Lussi sees him coming.

CLEMMET LUSSI

Oh. Great. Does he have to get involved in this? *

MADELYN Apparently everyone was hearing it. From way down the hall. You were screaming.

Clemmet, join us. And Lussi, don't worry, Robert's not gone.

CLEMMET I was telling Madelyn and the staff yesterday how well you've been doing. I'm surprised

about all this. I mean, she was doing really well for quite a while, weren't you.

ODIN'S HERE, FIRST VARIATION

Hey, remember, what two days ago? You were up and dressed. Talking to some of the other clients.

LUSSI I think there is an apocalypse coming. Robert wants to get out of here before it happens.

A silence. Some nervous sounds from the others. SAMANTHA *

Oh, yeah. Wow. Apocalypse. *

CLEMMET You were awesome in the talent show the other night, right? Who knew you could play

that instrument, so well too, right? *(Pause. No answer.)* Lussi? How we can help you? SAMANTHA *

Is she alright? * The Twins step forward and begin the *Shifting Tone*.

Then OTHERS (Sam, Oliver, Yulin) begin appearing.

MADELYN Sure. Something happened recently, didn't it. You look different. Something's off. Lussi? *

LUSSI You say that like a test. You say 'Lussi' like you weren't sure it was me.

MADELYN You have wonderful dimensions to your personality. And you can hold your center. You

don't need to listen to your voices all the time. You can keep it on an even keel. A bad storm can come up. It can get bumpy sometimes. That's normal.

LUSSI

A storm.

MADELYN I mean figuratively. Turbulence. It's normal.

LUSSI Don'ttellmeit'snormal. It'snot. It'snot.I'msorry. *

MADELYN Clemmet will lead a circle now. It is important for you. Stay with us. And then I think it

will be really valuable to keep our session later this afternoon. Wouldn't it be good to talk? *(Lussi nods slightly)* Sure it would.

Madelyn leaves. The Twins swell the Shifting Tone and hold it for a last second.

END: ODIN'S HERE

CLEMMET You have friends here Lussi, yes? Ok, everyone, let's circle. *(The others go for setting up*

the chairs.) Real friends, isn't that right? All of you? *(All ad-lib responses, as they set up)* And we really would love it if you joined us again. You're always welcome.

SAM You know it. We are here for you.

Yes, all of us.

Ok, yeah, sure, yeah.

OLIVER

YULIN

(Reluctantly)

17.

OLIVER It's the policy of this Facility. I mean, Yulin and I are just staff, but this place is special.

I'm saying this for everybody here. We are all going to help you.

THE TWINS Sure, yeah, yeah, I mean, for sure. *Let's get her things.* Hey, good idea. *(They go to get the*

dolls and bring them out for Lussi to play with.)

LUSSI Why did you set up a chair for him? Robert is leaving soon.

CLEMMET

He's here.

YULIN Robert had something off-Unit, but he is actually due back any minute now.

SAM Yeah. I'm sure he would have been the first down here to see what was going on.

THE WILD HUNT AND THE CREATIVE PROCESS

18.

He loves you. Sure. He is going.

THE TWINS

LUSSI

The Twins bring out small figures from two cloth sacks.

THE TWINS It's alright, come play, *You like to play with us*, hey, it's alright.

MUSIC: DOLL DREAD

LUSSI No it's not. *(She crosses and sits cross-legged in a corner.- to Clemmet:)* Izzie and Abby

are not leaving me alone. Again.

Clemmet catches Samantha's eyes, a knowing moment about this 'Izzie/Abby' business. Clemmet comes to Lussi.

19. We brought your dress-ups, Your lovely things. *Hey, see? We are always watching your*

back. Remember. We're your back-ups.

CLEMMET

(softer tone now)

They are really almost like you, aren't they, Izzie, Abby. They have their own problems, pretty serious ones too, wouldn't you say, and yet they don't forget you.

LUSSI

I wish they would.

SAM Ha! You're a cut-up. Love this girl. She is so funny. And with that darn accordion at the

show, it just needed more time to get warmed up, I think. THE TWINS

So funny.

SAM But no one was laughing AT you. Nooooo. WITH you.

LUSSI

(to Sam)

THE WILD HUNT AND THE CREATIVE PROCESS

THE TWINS We were laughing with you. *(Including Clemmet.)*

SAM OK, Mr C, it was actually a little tough. Maybe somebody said something to her. "The

girls", I think. Some thing critical. Of course I couldn't hear it. They weren't helping, I'm sure.

THE TWINS

I'm not sure I can trust you.

Hey! The Twins.

IZZIE

LUSSI

THE TWINS Yeah. *Why does she say it like that*? Wrong. We're the same as her. (*over-lapping with* *

Clemmet now)

CLEMMET I've reminded you before Lussi. Everybody is supportive here. You can bring some of

this up in your session later. With Madelyn. Remember, you're not alone.

THE TWINS But Mr. C you haven't heard her lately in the night. *Lussi thinks a terrible thing is* about to

happen now. I mean, It is about *to happen. We're all just so small, she says, and what is coming is big*. Real big. It's weird. *She's crazy. We aren't.* We really try to tell her. We try to tell her.

20.

Yeah, right.

SAM

The overlapping reaches a peak.

CLEMMET Those are all things we can talk about next time. We are going to have this circle later. *

OK, OK. ALL. RIGHT. Later! *(See Robert coming in.)* *

WHAT IS IT? HOW IS IT?

CLEMMET Here's our man. Robert! See, Lucci. Robert's here. Hey, buddy. Lussi has been looking

for you.

Lussi steps to Robert. He sees her, but turns away.

ROBERT She should get over it. She needs to get used to being alone.

Robert seems to be listless, and has no response to Clemmet. Clemmet clocks this and continues..

CLEMMET Buddy? Alright, okay, okay, but in the meantime, Sam, can you talk to Lussi? *

Clemmet crosses to talk to Robert. Oliver, Yulin start back to their work. Sam carefully moves to Lussi who is holding her doll figures. Sam is a patient but presents as if she is working there (Hints of her 'Loki' dimension).

END: DOLL DREAD

7-14-16

SAMANTHA * Sure. (To Lussi) You don't trust me, but you'll need me. You will. You will need to find * the invisible heart in the middle of anything and everything. *

LUSSI * What did you say? *

SAMANTHA * Surprise! (laughing) It's so funny, every time I do that. It's unexpected. I love that. Hey! *

LUSSI * Shapeshifter. *

She LAUGHS so hard she leans forward, her face to the ground. When she LEANS BACK, she has a mask on. A half-corpse face mask.

A silent moment.

SAMANTHA * Scared you didn't I. Get used to it if you want to free your brother. You are going to have * to travel to the deep cold North of existence. To ice and rock. And Shapeshifters. *

LUSSI * What are you? *

SAMANTHA * I'm... Sam! Oh you silly thing. But I'm on to something, right? *

ROBERT * I thought I said you should be alone. *

Madelyn comes in just as ROBERT pulls away from Clemmet and moves toward Lussi. *

WHAT IS IT, HOW IS IT

THE TWINS * Lussi, protect yourself. *Maybe we should tell him*. You're not alone. We're with you *

always. We don't need him. '

LUSSI *(to Robert)* I'll tell them everything. About what you did. And may never be forgiven for. *

Robert breaks from Clemmet. He moves to right in front of Lussi. He stands silent, as if gathering himself. When he speaks, it is with a new tone.

ROBERT You won't tell them. You will never say it out loud. It is too dark for you. I don't know if *

you even want to remember all of it. * LUSSI

Why wouldn't I. Who are you now anyway? Nothing you say reminds me of Robert. Don't do this. I need you here.

ROBERT They don't know what is coming. I warn them, but no one here can see me anymore. Too

dark. Right, everybody? You have stopped seeing me too. * LUSSI

Never. Robert, what is it? How is it that -- ? *

ROBERT -- you don't see me. I don't know why you think you do. Nobody here sees what is in *

front of them.

So...

He leaves. The others are on chairs on the perimeter of the stage. As they speak, they turn toward the audience - as if they were the 'dread'.

LUSSI WHAT IS IT, HOW IS IT, WHEN IS IT, WHAT IS IT

CLEMMET KNOWING IT COMES IN THE FEELING MOST FREE OF

IT

MADELYN THE DREAD THAT WE HAVE HAVING DRUNK OF IT

DEEPLY SURROUNDED BY ALL OF US WASTING COMPLETELY

SAM BUT...THINKING WE LIVE UNDYINGLY, SWEETLY

THE WORLD IS A PLACE WE WERE GIVEN TO LIVE IN

22.

OUR AN-CESTORS MOCK WITH THE FLOCK OF THE RAVEN THEY
KNOW WE WERE BORN WITH THE POISON THEY GAVE US

During this, a bed is moved slowly on. The Figure Operators move toward where the doll figures are.

ALL DON'T TELL ME... PLEASE DON'T TELL ME... IT'S

NORMAL... IT'S NOT... SOMETHING WE'VE ... SEEN BEFORE

LUSSI WHAT IS IT, HOW IS IT, WHEN IS IT, WHAT IS IT

KNOWING IT COMES IN THE FEELING MOST FREE OF IT

YULIN THE WOLF'S AT THE DOOR,

CLEMMET THE BEAR IN THE BASEMENT,

SAM THE POOL HAS BEEN FILLED,

MADELYN AND WHERE IS THE FACE MEANT TO

CLEMMET SMILE AT UNKNOWNS, SMILE AT CONCERN

LUSSI LIVE LARGE AND RAVE AT POLITICAL TURNS

The six doll figures are animated as spirits/puppets. Flying.

Lussi moves toward the bed, as if drawn to an old memory that can't be remembered entirely. The dolls separate and then hover above Lussi.

WORRY WE SHOULD

LUSSI

23.

ALL AND WORRY WE WON'T

LUSSI WARNINGS ARE FINE

ALL BUT CHANGES ALONE

WON'T GIVE BACK OUR WATER, OUR SEASONS SO DEAR TO US
RANGING FROM PARCHED TO NOT EVEN CLEAR TO US--

DON'T TELL ME... PLEASE DON'T TELL ME... IT'S NORMAL... IT'S
NOT. DON'T TELL ME... PLEASE DON'T TELL ME... IT'S NORMAL...

LUSSI

* *

IT'S NOT.

Land of in-between... Odin's World and the seen... Dead souls seeking ..
Live souls hiding... Oh, don't forget the times...

A LIGHT shift. In a shadowy light, the small figures (dolls) morph into
new movement. Ominous, in a strange way,

The SOUNDS of the Alter-World transition into the SOUNDS of the
facility for mental heath. It is a collage of muffled intercom, low
conversations, a distant TV and undertones played live.

LUSSI

*(Making a sequence of arm and hand gestures that seems to be in a
pattern, Lussi speaks as the song continues.)*

SAM walks about the bed, observing LUSSI. . She is not aware that the
doll figures are moving around Lussi. As she stands in front of Lussi and
speaks...

DON'T FORGET THE TIMES/ REPRISE

7-14-16

24.

HEY!

SAM

... the dolls collapse to the ground, becoming just dolls again.

SAM (CONT) What are we doing here? Huh? Taking the opportunity to
collect ourselves? Watching the

afternoon slip into evening, thinking about what needs to be done before night comes on? *(a new tone, Loki slipping in)* Something big is happening tonight, isn't it?

LUSSI

(Lussi's voice is different now too)

No. Not at all. You know, you're a patient, or somethign else. You don't work here so * stop pretending.

SAM What are you doing? All those movements. Are they protections from danger before we

lose the light?

LUSSI Don't forget. You're just another patient.

SAM Was that a yes-or-no answer? I mean, what were those hand things you were doing?

LUSSI I thought you said you wished me well.

SAM Oh, I get it. I'm with you now. Don't worry. I'm watching your back. Who's your

friend. It's me, Sam, remember? Do you want to hear about the secret?
LUSSI

The secret.

SAM Yeah, that secret of the invisible heart in the center of anything and everything. I actually *

don't know it, but I hear you do, but you may have forgotten. It will occur to you just as you really need it.

END: DOLL DREAD

7-14-16

25.

LUSSI I think you are mistaking me with someone else.

SAM Alright, alright. Let's do something fun. *

Hey, Izzie, Abby, Robert. Robert! *(to Lussi)* A Circle, but a special one.
LUSSI

I can't do this. *

SAM I got some information. We need a circle. Only with the ones who really count. I'm

thinking we should all sit down and just clear the air a bit. We don't have a lot of time. LUSSI

What are you doing? You can't call a circle. Besides, has anyone seen Robert? * SAM

I think it will help us. Just some-- TWINS

Special circle. Yeah, sure. *Good idea.* Good idea. * SAM

26.

--some.... we'll get some objectivity. About what's actually real here.

Right. Right. Right. Stop that!

Izzie has moved into the room in a hoodie. Abby has come in with a ribbon in her hair.

LUSSI IZZIE ABBY LUSSI

SAM Stop what? (directly to Lussi - twins-don't-exist version)

*

Izzie, let her speak for herself. * Abby, you both aren't helping here. Let Lussi speak for herself.

7-14-16

Robert is walking slowly behind the Twins. * IZZIE AND ABBY

She says we speak for her, THAT'S NOT TRUE. LUSSI

Always talking together... You know, I don't really like twins. * IZZIE

See, that isn't fair. Abby and I are friends. * START: NOT *

27.

MYSELF C'mon, Lussi. You are getting to be just like Robert. Pretty soon we'll have to drag you

ABBY out of your room just like we do for him. Right? *

Izzie sees Robert behind Abby. *

IZZIE

*Yeah. Yikes! Okay. He's here. (to Robert) We were looking for you. (to others) Robert's **

here!

Robert'shere. HiRobert. Robert moves into light in a separate area.

TWINS He used to be here. Whoever this is, I have no idea.

LUSSI

He's alright.

ROBERT I DON'T FEEL QUITE MYSELF TODAY.

A SENSE OF STRANGENESS COMES MY WAY MY HANDS AND FEET, THE WEIGHT OF CLAY

ROBERT, IZZIE, ABBY I DON'T FEEL QUITE MYSELF TODAY

ABBY

7-14-16

ROBERT I'M WEAK, I HAVE NO WILL TO TRY

ABBY AND IZZIE STUCK BETWEEN THE EARTH AND SKY

IZZIE AND ABBY NO HOPE, NO HOME, NO REASON WHY

I'M WEARY... ...WITH NO WILL TO TRY

ROBERT ROBERT, IZZIE ,ABBY MADELYN AND CLEMMET

A LOSS FOR WORDS IS YOUR DISEASE HEARING SOUNDS UP IN THE TREES

MADELYN TELL YOURSELF TO GET OFF OF YOUR KNEES

MADELYN AND CLEMMET A LOSS FOR WORDS IS YOUR DISEASE

MADELYN Don't you think, Robert? You can adapt.

ROBERT THE CLOUDS ARE FULL OF SORROW STILL THE GODS HAVE NOT YET HAD THEIR FILL

IZZIE NOTHING BREAKS, BUT SOMETHING WILL

THE CLOUDS ARE FULL OF SORROW STILL

ROBERT MEMORY IS THE DEATH OF ME

THE WILD HUNT AND THE CREATIVE PROCESS

LUSSI But you can't know what you can't see

Robert, best to stick with what might be

ROBERT, IZZIE, ABBY MEMORY IS THE DEATH OF ME

7-14-16

28.

MADELYN AND CLEMMET IF YOU WANT TO GO TO SLEEP

PRAY TO GOD YOUR SOUL TO KEEP THIS DARKNESS GROWING, DARKNESS DEEP WHAT IS GAINED IF ONLY SLEEP?

CLEMMET

Come on, you can beat this.

LUSSI MOTHER, CAN YOU HEAR HIM SIGH?

BLACK BIRDS TEAR ACROSS THE SKY

ROBERT, IZZIE, ABBY AS THE TIME IS DRAWING NIGH,

MOTHER, CAN YOU HEAR ME SIGH?

ROBERT DEATH WILL FIND ME BEFORE LONG

SOMETHING 'BOUT THIS PLACE IS WRONG

LUSSI I HATE THE WAY TIME ROLLS ALONG

DEATH WON'T FIND YOU, THAT IS WRONG

ROBERT I JUST DON'T KNOW WHAT ELSE TO SAY

I DON'T FEEL QUITE MYSELF TODAY. CLEMMET

Robert? Robert? Ah! I hate this place.

What? Lussi? Nothing.

LUSSI

ALL STOP. Silence. MADELYN

LUSSI

END: NOT MYSELF: In a single spot, Robert stands turned away.

29.

THE WILD HUNT AND THE CREATIVE PROCESS

30. I am going. Don't follow me. I'll fly in the sky with the raven band. Into the air.

UNDERSCORE: * ASTRAL HOVERING

LIGHTS SHIFT. Lussi sits alone. Madelyn, with * the small tree with lights, joins her. They could be * sitting on a ledge of a window, dangling their feet.

MADELYN I thought I'd find you here. (No response from Lussi.) I know more than you might

think. I need to. For the ones like you. Who worry and don't know about the grand, cyclical nature of the story. I know you know something of this story. Thor, Odin, Trolls, * The Dragrs. It starts at the creation, ends with the downfall of the cosmos. And the End is * called Ragnarock. You will be going toward the center of that soon. But you should know * something. Then it resumes again with the creation. Because of the invisible heart in the center of anything and everything.

Lussi turns. Open now.

LUSSI I'm hearing you but I'm not sure who is speaking.

Madelyn leads Lussi to stand in front of her. As if * Lussi needs to face the universe.

MADELYN I can't always talk to you like this. The world. The world isn't made of inert matter that *

follows fixed laws. Everything is conscious, willful, and spiritual. Consciousness isn't one organ like the brain or one species like humanity. Consciousness means anything we * perceive can also perceive us. Everything perceives us – tree, grass, bear, river, mountain – and by doing so, they are * enacting the same grand story, a sacred reality at the heart of life. Every life. *

(*Madelyn hands the tree to Lussi*) The world is full of persons, only some of whom are human.

Madelyn leaves as Yulin and Oliver appear.

END: ASTRAL HOVERING

ROBERT

7-14-16

OLIVER It is time. Now you're going to hear the real deal.

YULIN Finally. I always find it more interesting that way. (*Yulin takes the tree*)

What a lovely tree.

Love the lights.

As he brings it to its spot, LIGHTS AND SOUND shift, and the space returns to the world of the Facility.

Madelyn, Clemmet and all come in. (ad-libs around 'good evening') Oliver and Yulin help with the chairs. It looks normal, but we only hear some people talking.

Uhm. Yulin.

YULIN OK, yes? *(pause)* I'll take care of the chairs.

CLEMMET

OLIVER How about you? Would you like another water, Doctor? *(after her mimed, mute*

response) No problem. How about you, Lussi? YULIN

(snide, a bit)

Heh, no problem. WE WERE TOLD THIS PART OF THE FOREST WOULD

BE TRICKY, NOT THE EASIEST TO CONTROL.

OLIVER THEY HAVE SAID IT WAS A PSYCH WARD BUT IT'S

REALLY JUST A

YULIN

LITTLE DO THEY KNOW

31.

OLIVER CLEARING WITH SOME TROLLS.

OH, SOME SAY THEY ARE DOCTORS OR THE STAFF WITH YOUR HEALTH INTERESTS IN THEIR MIND.

YULIN THEY ARE SEEMING TO SUGGEST WE AREN'T AS

CAPABLE AS THEY'D LIKE, WHICH IS – ALL RIGHT – THAT'S FINE.

Yulin grabs the clothes tree with the 'Madelyn coat' on a hanger. It is used as a puppet version of her. Oliver and Yulin slip into a gypsy-glide-dance that lets them feel their mysterioso power.

OLIVER LITTLE DO THEY KNOW, I'VE BEEN DEALING WITH

SUCH BEINGS ...

AND WHEN THEY REALIZE THAT IT'S ME THEY WILL BOW IN HUMILITY

ANDPAYSOMEHOMAGETOMYGREATNESS WHICH RIGHT NOW I WOULD ADMIT THEY DO DENY.

YULIN OH THERE'S SOME CHARM IN THESE WOODS AND IT

HAS SOME CREATURES WITH NICE FEATURES... NOW THESE FOUR HERE PARADE AS PATIENTS AND TALK BABBLE ON MANY OCCASIONS

TO MAKE IT SEEM THAT THEY ARE HERE AND NEED SOME HELP.

OLIVER I TOLERATE THESE LITTLE SPRITES AND LISTEN TO

THEIR GRIPES AND FIND QUIET LITTLE WAYS TO PROTECT THEM. BECAUSE THESE COMPLICATED TROLLS PUSH THEIR THERAPIES ON THEIR SOULS, AND I JUST REJECT THEM.

* * *

32.

7-14-16

OLIVER, YULIN AND THE STAFF THAT READ AS FRIENDLY ARE –

ELFIN BEINGS SO SHIFTY IN THEIR STYLE PASSIVELY SEEKING MY PERMISSION TO KEEP THE PATIENTS IN SUBMISSION FOR A WHILE JUST A WHILE. LITTLE DO THEY KNOW, I'VE BEEN DEALING WITH SUCH BEINGS ... AND WHEN THEY REALIZE THAT IT'S ME THEY WILL BOW IN HUMILITY

OLIVER, YULIN (CONT) AND PAY SOME HOMAGE TO MY GREATNESS

WHICH RIGHT NOW I WOULD ADMIT THEY DO DENY. DIDN'T YOU SENSE THIS PART OF THE FOREST WOULD BE TRICKY, NOT THE EASIEST TO CONTROL.

OLIVER

Don't you find it that way?

OLIVER, YULIN THEY HAVE SAID IT WAS A PSYCH WARD BUT IT'S

REALLY JUST A CLEARING WITH SOME TROLLS. LUSSI

I don't understand.

OLIVER OH, SOME SAY THEY ARE DOCTORS OR THEY ARE

THE STAFF WITH YOUR HEALTH INTERESTS IN THEIR MIND.

LUSSI

Who are you?

YULIN THEY ARE SEEMING TO SUGGEST WE AREN'T AS

CAPABLE AS THEY'D LIKE OLIVER

33.

You've heard that, right. THAT'S NOT RIGHT.

YULIN

7-14-16

I don't think--

THAT'S NOT RIGHT. I... I... I don't trust you.

LUSSI

OLIVER, YULIN LUSSI

OLIVER, YULIN

THAT'S FINE. It's fine.

Wait. It's really fine.

*
THE WILD HUNT AND THE CREATIVE PROCESS

Pause.

YULIN Yulin exits.

LUSSI

OLIVER

LUSSI Wait! I get it. I know that you are trying to tell me something, even with all that pretending *

that you're not. Fine..., alright. That is a start. It's not a metaphor, is it. You are saying 'Trolls' and you mean....

START: ODIN'S HERE

OLIVER Trolls. Yes. Here. Tomte. Sluagh-elfins. Even Draugrs. You just thought it was in your

comic books, didn't you. Thor. Odin. And if you get to met just one, I'd say Odin. *

LUSSI You don't think I can see them. Spirits dwelling inside elements that would never seem *

animate. Inside anything and everything.

OLIVER LUSSI

7-14-16

34.

OLIVER I don't think you can see very much at all. And you are going to need to learn to see what

others can't see. And to speak a new language. Some of us think you may be ready. You * are going to make a journey soon.

LUSSI

How do you know? I can tell you, but you couldn't know the truth of it. To speak. The sacred realities. It is a *

OLIVER matter of perception and knowing that those stories perceive you. *

Who are you?

LUSSI YULIN *

He just works here. *

THE WILD HUNT AND THE CREATIVE PROCESS

OLIVER

(sly now)

Oliver. I'm on the staff. You have been here long enough to know that. Just wait, and * listen to the texture of the wind. You'll hear a language that holds all of existence in its * hands. *

SHORT: WIND AND STORM

Loud SLAM, and Lussi runs to the shutter, alone in a spot of light. She manages to close it but the wind * remains. *

IYN WARDZBACK

Lussi, alone, begins to find the first words of "Wardzback", as if channeling. Then the words just flow. (// = sharp breath inward, --- = hold out/trail out)

AAAH // AAAH // AAAH // NE EH EERIE AFALOOSHN NEH-- EDNOMNASNEH // AAH --- SKI ABI AH OOSTARI AAAH ----

SKIDNASKIA OOSKARIDNA AH EEEEEEE

* * * *

7-14-16

35.

NAMNOSKIADNO OOSTARIA EEEEEE STEADNORSKIA OOSTARIA EEEE

AAAH // AAAH // AAAH NE EH EHRIE EERIE AFALOOSHNEH EDNOMNASHNE // MEEMEH--NDNOYSNOOS // SNI AFNIA OOSTARIA-- BIA OOSTERDNEW OBSIERFIASHIODNEH A

TERKADNORTH PORDNAVEH // OG SURD SIGNURDNAVNEH // POR NORD UBSERVARGARD //

AAAH--- EERIE EERIE AFLAOOSHN NEH EDNOMNASHNE

Clemmet, transformed as a creature, begins a slow walk.

A projector is brought out, set on the ground and some figures gather around it - almost like around a campfire - to project shadow-images.

(A story is told. Following each incident in the story, the shadow-images reveal the sequences of dark- crisis, forest, a fire, word-talking, transition-to- bright.)

THE WILD HUNT AND THE CREATIVE PROCESS

(Transitions between shadow-images are indicated in the text with the underlined words and ...)

A DRAUGR/CLEMMET When - after a time of peace - the world of the tribes would face a crisis... and begin to

separate into factions and go into decline... When the most fearful talked of Ragnarok, the great twilight... That is when the Leader - a Draugr - would go to a certain place in the forest... he would light a fire... Then he would say words... *(sung: 'words backwards'/ a book image)* The words would hold all existence in their hands. The words would weave the great tale of the circles within circles. They would sanctify all of existence, and soon... the trouble would pass and the light would return to the tribes.

36.

7-14-16

Madelyn transformed as a spirit, continues the pattern of walking

THE DISIR/MADELYN Later, when she had passed away, the next Guardian Leader - a Disir - when challenged

by a crisis that threatened to tear apart the tribe... she would go to that same place in the forest... She would light a fire... But she didn't know the words.... *(sung: no words, just sounds)* As it happened, it was enough to come to the place and to light the fire... And the conflict for the tribes would pass.

Samantha transformed as a spirit, replaces The Disir in the walking pattern.

THE SLUAGH-ELFIN/SAM And then when the next Leader - a SLUAGH-ELFIN - would face a crisis... she would

go to the place in the forest... but she didn't how to light the fire... she didn't have the words but she hoped it was enough that she had come to the right place... and it was enough.

A Draugr/Clemmet assumes the walking pattern, moving in a new way now, a slow-motion lurch.

A DRAUGR/CLEMMET And, later, a strong Leader - said to be a Goodwalker. As you, Lussi, are a good walker. *

She could lie in a state of dreaming and leave her body to astral travel for four days each * season - was confronted with a crisis. That crisis

began to tear apart all the families of the tribes... she didn't know where to go in the forest... and she didn't know how to light the fire... and she didn't have the words. But she said, I hope at least -

LUSSI - at least - I can tell the story. The story of the story's power. A story using words that can *

hold all existence in their hands. Words that can weave the great tale of the circles within circles. The invisible heart that can sanctify all of existence.

END: IYN WARDSBACK

THE TWINS/ IZZIE, ABBY (*Abby/ Italics, Izzie/* straight font, *Unison/*

underlined.) *Sam enters.*

Maybe not. Goodwalker, sleep. Sleep. *This is the season when you will be able to travel * high and far, to truly see from your dreams.* (Oliver bends, Lussi leans to sleep) *

37.

7-14-16

LUSSI

Robert. Robert says we don't need the story. That --

THE TWINS *we've* lost the thread of the story anyway

But when we lose the story - *the story of It, the world*. And the story of Us, humankind - then we've lost the power *to soothe the crisis.* Let Robert go. *

SAM There is only crisis. And destruction.

The lights shift and Lussi slowly curls warily into a sleeping position.

LUSSI

SAM & THE TWINS

38.

Robert, is he lost? He lives with his dark memory. He is lost. A lost soul, waiting.

*Robert comes in, and eventually stands near Lussi. * Although 'asleep', she moves and speaks from her * sleeping consciousness.*

START: THE HUNT Wind. The music begins in slow, sustained tones.

SAM The Hunt. It is coming. The wind, strong one second and then still. The empty, waiting *

SAM

night. A barking nearby. Then far. Whining, From under the floor. A grey, waiting half- light. *(Robert holds Lussi's head)* The wind has come. The dark clouds pile high. Dark and twisting. Then-

A high sound

* *

7-14-16

The ground shifts. NO.

39. SAM *

LUSSI SAM

And a swirling hole in the storm clouds opens. * LUSSI

NO.

SAM * Down they come. The incarnate. The shards of beings riding shards of steeds. They

come through the sky. Few will hear it or see it. Some might see a flock of ravens * speeding down from the horizon. *(Robert moves away)* Squint and you will see them. * Your brother wants to be gone. Gone with the Hunt, the Wild Hunt. Gone so you can't find him.

A blackness.

*Lights up on Robert. He starts to speak through the * restless wind gusts.*

ROBERT He... He is gone. *

LIGHTS AND SOUND transition back into the * Facility world.

LUSSI

*(She rises up, sensing something, * breathing deeply)*

No. Robert. YOU CAN'T. YOU CAN'T GO.. ROBERT--- Madelyn is at the door. Robert is gone.

THE WILD HUNT AND THE CREATIVE PROCESS

MADELYN ---LUSSI. (*she steps closer*) Listen, Lussi. I don't know what to say. I'm so sorry. *

7-14-16

LUSSI

(*Suppressing*)

You don't have to feel sorry. I have this under control. I used to know magic. I'll remember it.

MADELYN Well, I'm not sure about all that. But I do think your grief about Robert will happen when

the time is right. Sometimes the ache is just too hard to bear. But at some point, you should just go ahead and grieve.

LUSSI

(*a quiet, manic denial*)

Why should I do that? I don't need to. I don't need to grieve. I lived in a time when mortals became immortals. When immortals would become human for a while. That's what happens.

MADELYN Robert is immortal in his own special way. But he also won't be here at the Facility any

longer. No, he will. People are going to say, 'I'm sorry to hear about your friend."

Robert is my brother.

Yes, so much like a brother.

The Twins have entered slowly, sensing Madelyn's meaning, a SUPPRESSED MOANING filling them. They can barely talk, but Madelyn can only hear and see Lussi. Lussi can only hear and see Madelyn.

ABBY

LUSSI MADELYN LUSSI MADELYN

Aaaaah. What is she saying? You and he had a special connection. You will always be able to celebrate that.

40.

MADELYN

7-14-16

IZZIE Nooo. What's happened? Nobody's said anything to us about anything.

MADELYN It is always hard for those that have to somehow make sense of what has happened. They

can feel like it is their fault. What? Oh no, please, Robert! And that would be wrong. He was a brother. My best... You gave him all the love you could.

LUSSI

(Tears coming through a manic denial)

I'll get him out of this. I always have.

MADELYN Lussi, he is gone. He wasn't happy here.

A MOANING RELEASE from the Twins as they feel it completely now. The truth. Still, Lussi keeps it away.

He wanted some rest, after a life that just never was happy.

THE TWINS My brother. I don't have any more. Family. Please. Please.

LUSSI

(insistent, needing it to be true)

You live in this world but you are blind. You just aren't seeing the life around you. MADELYN

41.

ABBY MADELYN IZZIE MADELYN

*

We didn't see this coming. No. Hewouldn'tleaveme.

LUSSI

7-14-16

MADELYN I didn't see that it would be his choice. To leave. I wish I had.

I didn't get to say goodbye.

MADELYN Believe me, I don't have all the answers.

IZZIE The last thing I said, so mean. I want to tell him--

LUSSI

(Beginning to crack)

42.

I want to tell him.

I want to tell him.

ABBY

LUSSI

(The pain floods in)

I didn't get to say. I love him.

I need to say something to him. Please, he is not gone. Please.

Madelyn clasps Lussi before she can fall. The grief is coming into Lussi in deep breaths and quiet sounds. They spin slowly until Lussi slips down and Madelyn cradles her.

Madelyn comforts her, then shifts to telling us the story.

MADELYN A BROTHER AND A SISTER ONLY HAD EACH OTHER

OH THE COLDEST WIND BLOWS THE BROTHER WENT AWAY, SHE WAS LEFT ALONE CRIED OH THE DREADFUL WIND SHE WATCHED AS HE CHOSE TO LEAVE HER THERE

LUSSI + MADELYN OH THE COLDEST WIND BLOWS

QUIETLY: BROTHER AND A SISTER

7-14-16

LUSSI A STORM BLEW HARD, HE BECAME THE AIR

LUSSI + MADELYN OH THE DREADFUL WIND

HE FLEW IN THE SKY WITH THE RAVEN BAND OH THE COLDEST WIND BLOWS

LUSSI HE SAID, LEAVE ME ALONE, NEVER BRING ME HOME

LUSSI + MADELYN CRIED OH THE DREADFUL WIND

THE WILD HUNT AND THE CREATIVE PROCESS

MADELYN THEN OUT OF THE WOODS CAME A FIDDLER FAIR

OH THE COLDEST WIND BLOWS HE FOUND 30 STRANDS OF HIS SWEET DARK HAIR. CRIED OH THE DREADFUL WIND HE MADE A FIDDLE BOW OF HIS LONG BROWN HAIR OH THE COLDEST WIND BLOWS MADE A FIDDLE BOW OF HIS LONG BROWN HAIR CRIED OH THE DREADFUL WIND

LUSSI, ABBY, IZZIE HE MADE FIDDLE PEGS OF HIS LONG FINGER BONES

OH THE COLDEST WIND BLOWS HE MADE FIDDLE PEGS OF HIS LONG FINGER BONES CRIED OH THE DREADFUL WIND

MADELYN + LUSSI HE MADE A LITTLE FIDDLE OF AN OLD BREAST BONE OH THE COLDEST WIND BLOWS THE SOUND COULD MELT THE HEART OF A STONE CRIED OH THE DREADFUL WIND AND THE ONLY TUNE THAT THE FIDDLE WOULD PLAY WAS OH THE COLDEST WIND BLOWS

MADELYN AND THE ONLY TUNE THE FIDDLE WOULD PLAY

WAS OH THE COLDEST WIND BLOWS

ENDS: BROTHER

7-14-16

43.

Please... Robert...

No, Robert. Please.

AND A SISTER

QUIETLY: THE LONELY TRAVELER (O, C, Y)

PROJECTIONS: The lights dim up on a landscape of dark forest. In a POV, we see a fog floating through trunks of trees and the rocks have faces. We are feeling as if we are floating with a direction through a landscape of hovering souls that are just out of sight. The POV swings, blackout.

LIGHTS SHIFT to reveal a rough landscape. A * THREE-FOOT-TALL TRAVELER in a hood, is * making his way up a ledge. LUSSI, in a pool of * light. *

LUSSI

He looks back, and then with resolve resumes the climb. BLACKOUT ON THE SMALL * TRAVELER. *

LUSSI

BLACKOUT ON LUSSI. Lights up on a FULL- * SIZE TRAVELER *(Robert)* - also in a hood - * making his way through a crevice. *

In a separate area, a spot of light brightens on the * back of a head. ODIN. As he speaks, he turns into * the shaft of light.

ODIN Welcome to Odin's world. At the center of the spirit of the cosmos is an ash tree, Yggdrasil

('IG-druh-sill') which grows out of the Well of Urd. Odin's realm is the Nine Worlds. They are held in the branches and roots of the tree. Sometimes I speak of it as my ash tree of the horse.

7-14-16

44.

The eight-legged horse in the tree is a means of transportation between the nine worlds. Urd means destiny. The horse and I carry that knowledge for the Well of Urd can be called the Well of our Destiny.

(THE LONELY TRAVELER CHANGES)/ THE TREE OF THE NINE WORLDS

LIGHTS SHIFT. Both the small and full-size * travelers, in parallel journeys, continue on. A * Shadowy Draugr is revealed in a pool of light. *

DRAUGR/CLEMMET Yggdrasil and the Well of Urd. They are the center of the myth. The myth carries a

perceived meaning. It tells the essence of something. It's not just describing the thing's physical characteristics.

(The Draugr shifts.) * The ash tree Yggdrasil and the Well of Urd. These are not thought of as existing in a

single physical location. These dwell within the invisible heart of anything and everything.

ODIN The Nine Worlds exist in the invisible heart of anything and everything.

DRAUGR/CLEMMET * It is a tale told for more than a thousand years. The tale does not deny any of those beliefs * that have come after. How could it? It came before. *

ODIN You have entered a realm that has no true name. Those of us here just call it 'tradition'.

[MUSIC FADE] *(Pause.)* You have traveled here. I ask you. Do you want to go back?

The THREE-FOOT TRAVELER rises up. removes his small hood, the FULL-SIZE TRAVELER also removes his hood.

As he

IN THAT MOMENT, we see that the Small Traveler is a Draugr. And we see that Robert is also now a Draugr.

7-14-16

DRAUGR/ROBERT It is not necessary. She will come. She will try to come here. *

DON'T FORGET THE TMES -REPRISE (O, C, Y)

Lights only on the Facility. Lussi urgently begins * the 'protection' rituals.

LUSSI

*(To herself, whispering the ends of each * line.)* *

Land of in-between... Odin's World and the seen... Dead souls hiding .. Live souls seeking... (End: Don't Forget The Times) I know where he is. I am told by a moat in my eye. An itch in my ear.

ODIN'S HERE- REPRISE

(A tone is heard.) And in that second I hear something. *(A tone of two notes is heard- The Twins)* Time is stretched... *(Again, the tone of two notes)*

I stretch it. So you can see.

Odin.

Old-en. Olden times... Odin, a god. Shape-shifting times. Odin knows...

ODIN

THE TWINS

LUSSI THE TWINS, ODIN LUSSI THE TWINS

* *

46.

7-14-16

47. ODIN *

...that you'll find Robert in the tree of the Nine Worlds, and the leaves of the, Eight legs, * the ghost horse of the Austergard. You will face The Wild Hunt, the horsemen and their * steeds and their incarnate dogs and hunting hawks, Shape-shifters. They are coming, To * find you. *(Odin disappears.)* *

You. Won't find him.

THE TWINS (OFF)

LUSSI They came , they took my brother, and now I have to follow. *(Pause.)* I will see him again. *

You won't find him. Maybe, the storm will come again --

You can't. You are with the Living.

THE TWINS

LUSSI THE TWINS LUSSI

-- And I will be gone. With the Hunt, the Wild Hunt. Gone to their worlds to find him. ASLAM. THREEDRUMBEATS.

BLACKOUT. Then LIGHTS UP on a separate * realm.

LOKI/ SAM (To Robert. Whispering.) *

Yggdrasil. Is not the true name. To you. Your destination is no destination. You are unfinished. You won't rest in this place. It is your fate. Half being. You have half- * destroyed. A weak destruction. You need to continue to destroy. Fully. And then you will be free. Go Back. Destroy her. *

DOLL DREAD/REPRISE

LIGHTS SHIFT. In a repetition that is slightly changed from what we saw before, a woman enters in Madelyn's coat with YULIN.

Lussi? What is it?

I'm sorry.

(a weak parody of Madelyn)

LUSSI

(She is not lost now. But thinking.)

48. It is ODIN taking off the coat as if just getting to the *

Facility. She hands it to YULIN who hangs it. * ODIN

ODIN You aren't sleeping well, are you. You are getting quite restless.

LUSSI

(Seeing the charade)

I need... I need to be awake... Right now. YULIN

Were you up all night?

You were told this part of the forest would be tricky. It wouldn't be the easiest to control. ODIN

They told you it was a psych ward. It's a clearing with some trolls. *

YULIN They are seeming to suggest you aren't as capable as they'd like. You're not capable.

That's alright. It's all right – That's fine.

Odin and Yulin hold in place. Waiting. (Fade out: DOLL DREAD)

Moving now slowly around a still Lussi, who is watching them circle.

LUSSI I'm of a different sort than he is now.

You are with the living.

ODIN & YULIN

START: GATHER * 'ROUND

ODIN & YULIN (Whispering) *

You remember now. You remember you are a Goodwalker. You were the leader who could remember only the story of the story. You could lay for four days of every season and leave your body. Your twined spirit could travel far and fast and through matter to the center of every thought.

LUSSI Goodwalker. I have a twined soul who travels into another realm.

A CHORD, as she touches the keys.

Old knowledge that is in the right-sided room of my brain-house. That knowing which could let me see the unseen.

YULIN The Twins appear, as if Odin has drawn them. *

THE TWINS * Lussi. *

LUSSI

The twins.

ODIN They are your twined soul. They always existed only as two aspects of you.

LUSSI

No, they were patients too. The staff let you think that. Part of your treatment. Sorry. I should have mentioned *

And you have a twined soul.

something about that.

YULIN But now... *

FULL: GATHER 'ROUND

During an instrumental beginning, Lussi calls to the dark.

49.

LUSSI There are these twin spirits inside me. The ones I haven't invited, the ones who have

always been there. They will make the journey. THE TWINS

Not us, please. We are both here and not here. We can't leave you.
LUSSI

I won't wait for the Hunt to come for me. You will make the journey.

Madelyn and Sam. They carry Lussi's totem dolls. During the following, they attach them to The Twins

LUSSI HEY, GATHER 'ROUND, GATHER 'ROUND. GATHER

'ROUND

LUSSI, M, S HEY, GATHER 'ROUND, GATHER 'ROUND. GATHER

'ROUND. HEY,

HEY, HEY,

LUSSI, M, S, Y, C

ABBY HEY, GATHER 'ROUND,

GATHER 'ROUND. GATHER 'ROUND HEY, HEY, HEY,

IZZIE IZZIE AND ABBY LUSSI, THE TWINS

ALL HEY, GATHER 'ROUND, GATHER 'ROUND. GATHER

'ROUND HEY, GATHER 'ROUND, GATHER 'ROUND. GATHER
'ROUND HEY, GATHER 'ROUND, GATHER 'ROUND. GATHER
'ROUND

7-14-16

50.

HEY, GATHER 'ROUND, GATHER 'ROUND. GATHER 'ROUND

GATHER ROUND/VARIATION

Lussi stands with the ACCORDION watching THE TWINS weave and spin to a high position. They spin above the others (ALL) who have joined the song. The two DOLLS the Twins have carried separate and spin above the Twins. The dolls shed their silky cloth, and the SILKS - spinning and darting - assume the spirits of the twins. As the twins and dolls DROP away, the Silks flash upward into a * Bright Light. THE LIGHTS SHIFT. *

ALL * HEY, GATHER 'ROUND, GATHER 'ROUND. GATHER * 'ROUND *

TEMPORARY * SUMMARY OF THE * LAST SECTION OF * THE PLAY: *

------ * *

THE FOLLOWING THREE PAGES ARE A SUMMARY OF WHAT IS STILL TO BE * WRITTEN. IN JULY 2-16 AT NEW YORK STAGE AND FILM'S WORKSHOP, * BILL CAME UP ON STAGE AND READ THE FOLLOWING TO THE AUDIENCE. * THE LAST LINES WERE SPOKEN BY THE ACTORS *

THE WILD HUNT AND THE CREATIVE PROCESS

OK, so you can see, Lussi (and probably me too) is in deep. *

*(I've been told I should take three minutes and give you a sense of resolution. We have * placeholders for most of this, but , as Samantha might say, it doesn't hold up yet in a court * of law . Since we showed you a few place holders as it is... here's some of what we are * thinking)*
*

So, Lussi is operating now with the idea that we might be able to think and do things in the * ancient cosmology of the cold North that we can't quite do otherwise. She sees that we * haven't had success with whatever of the belief systems we've been trying to use to solve * our big problems. And particularly, her big problem.

51.

52. Now she has her new strength as a Good Walker. She is in her sleep, but she is sticks *

with her conviction that she can recover her lost brother. *

Her grief has driven her to send The Twins, avatars as the gaming world would say, * through the mortal coil. To travel to the astral realm, the Tree of the Nine Worlds, the realm * of the stars. Or as Google says, a nonphysical world with various psychic and paranormal * phenomenon connected to it. *

Plot-wise, --- Lussi explores the idea that a deeply grieving soul like her's will find what it * needs to not only soothe the tear of separation but to imagine a way to heal the illness that * has become manifest in the object of her strong love. (That''s a song). *

That brother. That part of him-her-us that is surprisingly dark and that clings to the * apocalyptic commitment to implode. *

He's done a dark deed. Lussi sometimes can and sometimes can't acknowledge what it * was. But Robert has been told he hasn't gone far enough. *

Lussi has found a way in her life to manage to tolerate her bland and sorrowful days with * strength. (that's a song). *

But Robert becomes at first half-present to her as her evening turns to night. That is a song * that transitions into his revelation that he has returned to the physical world to finish what * he started. Since he has wounded someone he loves that much, he will be free when he *

THE WILD HUNT AND THE CREATIVE PROCESS

finishes it. * In a moment of heart-pounding fear (hopefully it will be), this naming of the un-nameable, * this raw unavoidable re-enactment of that buried unforgiveable act, (all happening in a * song) in the middle of all that, she inadvertently discovers - with her new language - a kind * of door to open that Robert.can't help but move through. *

And he shape-shifts - as is the nature of beings of this ancient world (and sometimes * ours...) - to a being that is even older than an unforgiven one... (You may recognize that * being as one you probably have encountered yourselves in a dream or two - though it may * have had piano accompaniment) *

Lussi still faces her conviction that her world and ours is deluded with falseness during the * Winter Solstice. A burr in her bonnet so to speak. (But this song about that is a tad less * fraught than one at the beginning) Madelyn has some perspective about honoring that * season.

We are back in the Health Facility. Like at the beginning of the play.

53. Madelyn has found Lussi. With her small tree. *

MUSIC: TAMARACK * - REPRISE *

ALL * O TAN--------, O ----------ENBAUM, * HOW ------ -------- THY BRANCHES * -------- GREEN WHEN ----------- HERE * ---- IN THE COLDEST TIME OF YEAR. * O TAMARACK, O -------------- TREE, * -------------- THY BRANCHES *

MADELYN * Mythology. It is important. It is a kind of a language. A kind of... *

LUSSI * I know you think of it as just a great story. It's a story about a forgotten story. They want * us to remember it. The invisible heart at the center of anything and everything. *

MADELYN * Maybe our mythology is more like yours than you think. Peace on earth, good will... * towards... *

LUSSI * Well. Yeah. *

MADELYN * Good will. *

LUSSI * Good will... Towards.... Us. *

THE END, POSSIBLY * *

NOTE: THIS SONG WILL BE INCLUDED SOMEWHERE IN THE FINAL SCRIPT: *

THE WILD HUNT AND THE CREATIVE PROCESS

All begin to move onto the stage.

LUSSI WHEN YOU HAVE SEEN WHAT YOU MUST SEE

ALL AND ASKED WHAT YOU MUST ASK

THE GATHERING WILL ACCEPT OF THEE THIS DAY OF RECKONING

AND WHEN THIS DAY HAS COME AT LAST WHERE WILL WE FIND OURSELVES FOR WE HAVE ASKED WHAT WE MUST ASK AND SEEN WHAT WE HAVE SEEN

THIS RECKONING THIS RECKONING

ROBERT, OTHER MALES AND WHEN THIS DAY COMES AT LAST

WHERE WILL YOU FIND YOURSELVES

Odin is revealed in the midst of a fierce fury of movement. It has elements of ritual and war.

THE STORM THAT LOOMS AND GATHERS FAST AND SPARES NONE IN ITS PATH

LUSSI, THE TWINS WHEN I HAVE SEEN WHAT I MUST SEE

ALL AND ASKED WHAT WE MUST ASK

THE GATHERING DEMANDS OF THEE THAT YOU MUST LET US PASS THAT YOU MUST LET US PASS

The Draugr/Robert begins to seep away.

GROUP 1 THIS DAY OF RECKONING THIS DAY OF RECKONING THIS DAY OF RECKONING

AHHH
AHHH
AHHH

GROUP 2 THIS RECKONING THIS RECKONING THIS RECKONING

GROUP 3

ALL AND YOU MUST LET US PASS

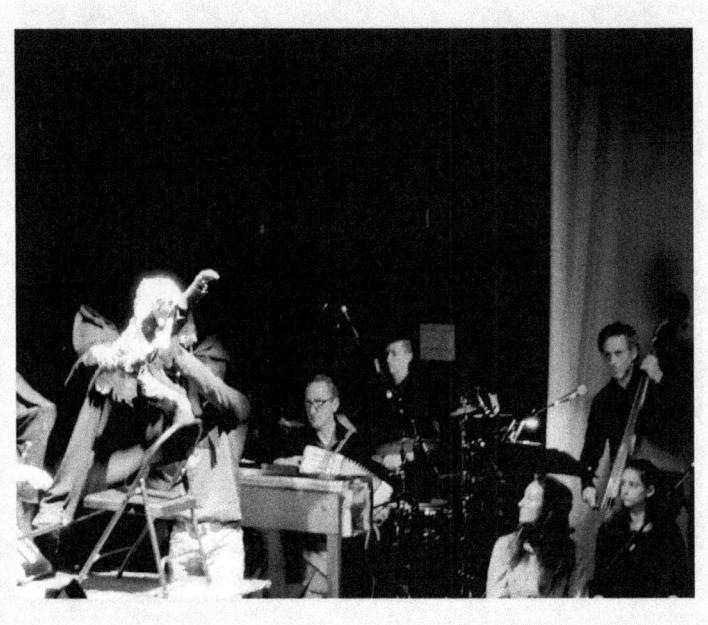

THE WILD HUNT AND THE CREATIVE PROCESS

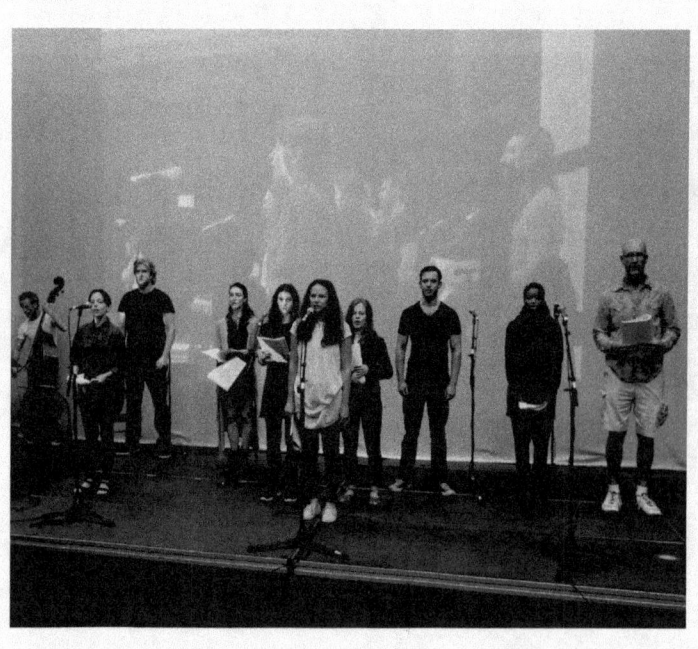

THE WILD HUNT AND THE CREATIVE PROCESS

THE WILD HUNT AND THE CREATIVE PROCESS

THE WILD HUNT AND THE CREATIVE PROCESS

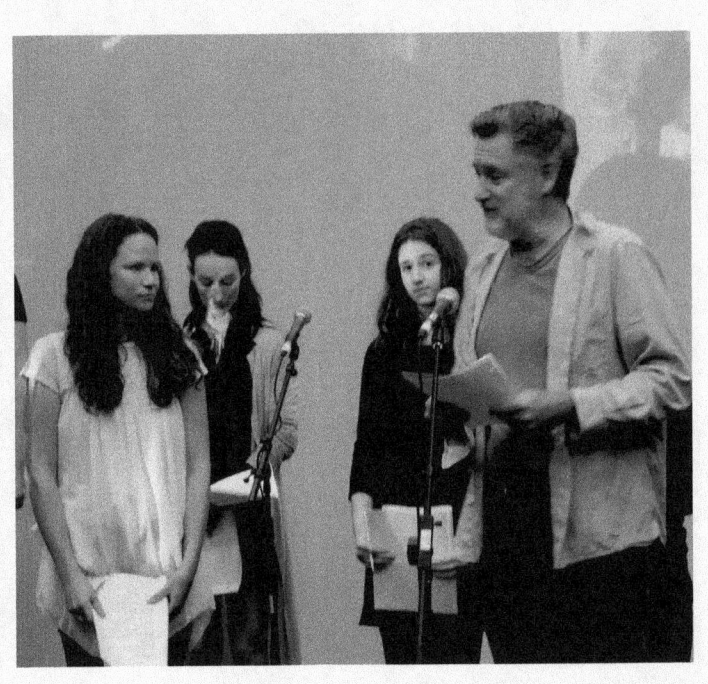

THE WILD HUNT AND THE CREATIVE PROCESS

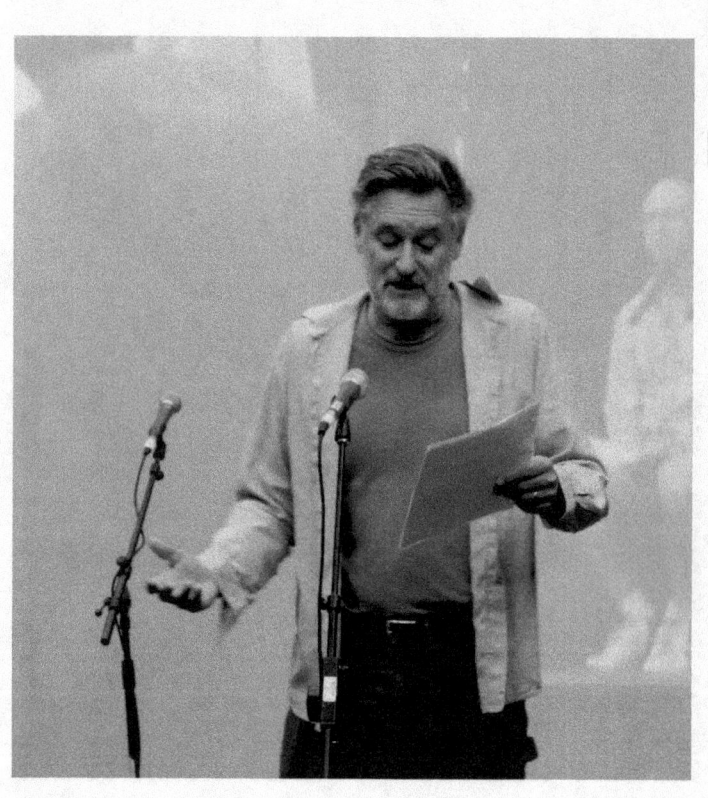

THE WILD HUNT AND THE CREATIVE PROCESS

THE WILD HUNT AND THE CREATIVE PROCESS

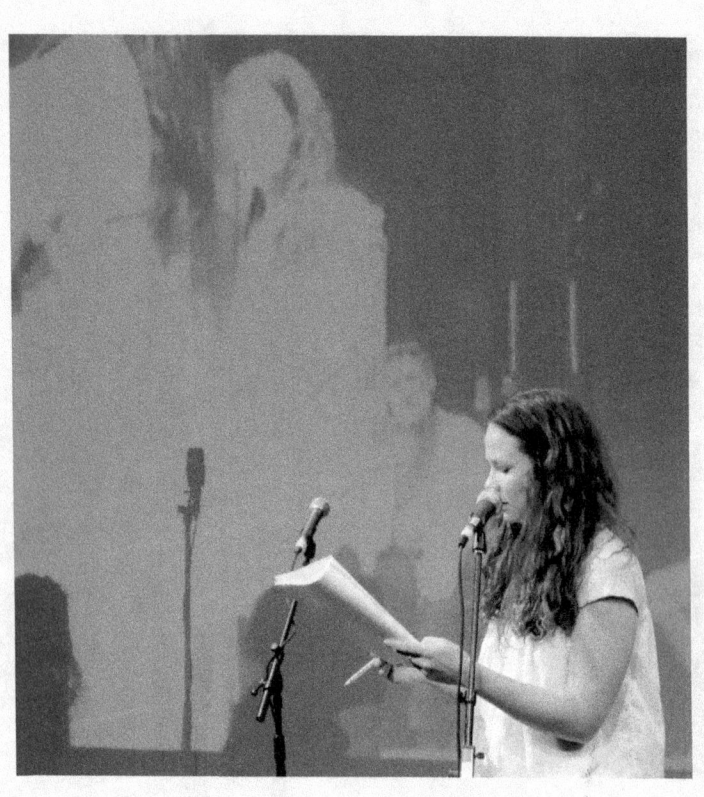

THE WILD HUNT AND THE CREATIVE PROCESS

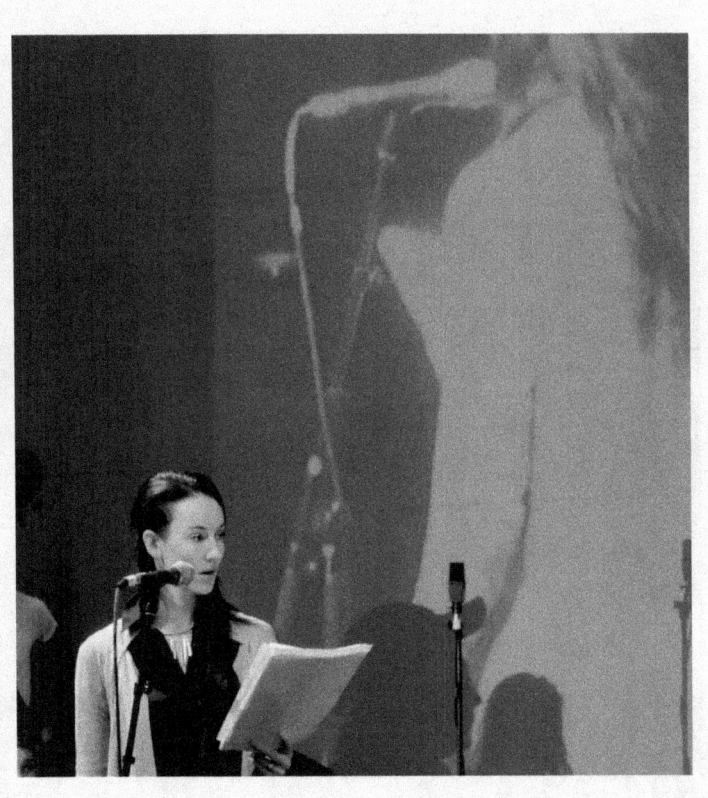

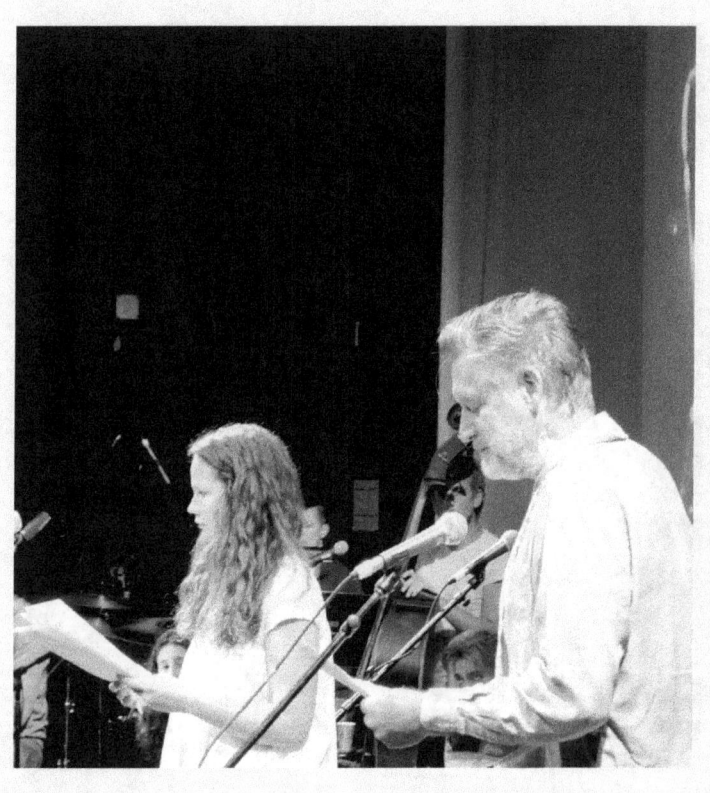

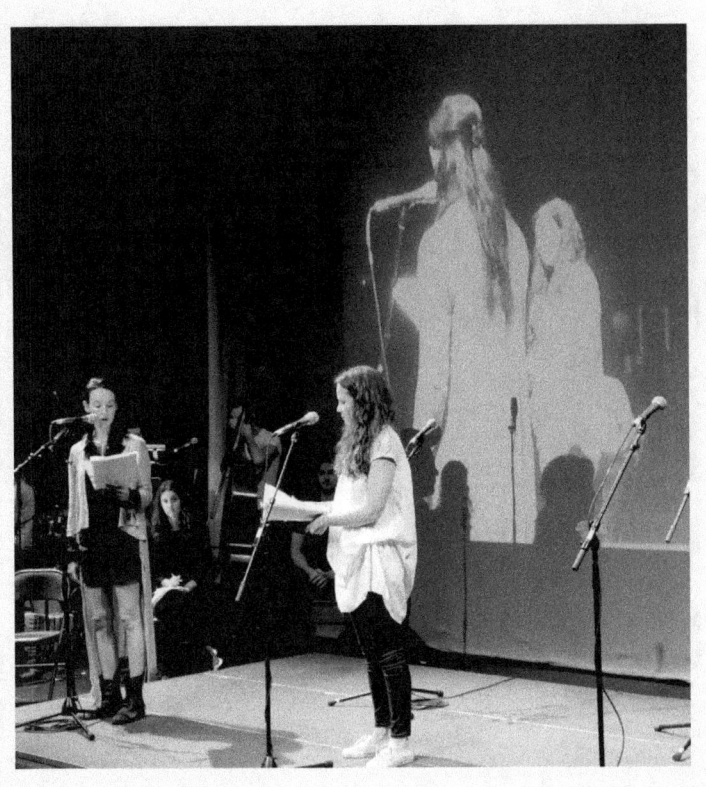

THE WILD HUNT AND THE CREATIVE PROCESS

THE WILD HUNT AND THE CREATIVE PROCESS

THE WILD HUNT AND THE CREATIVE PROCESS

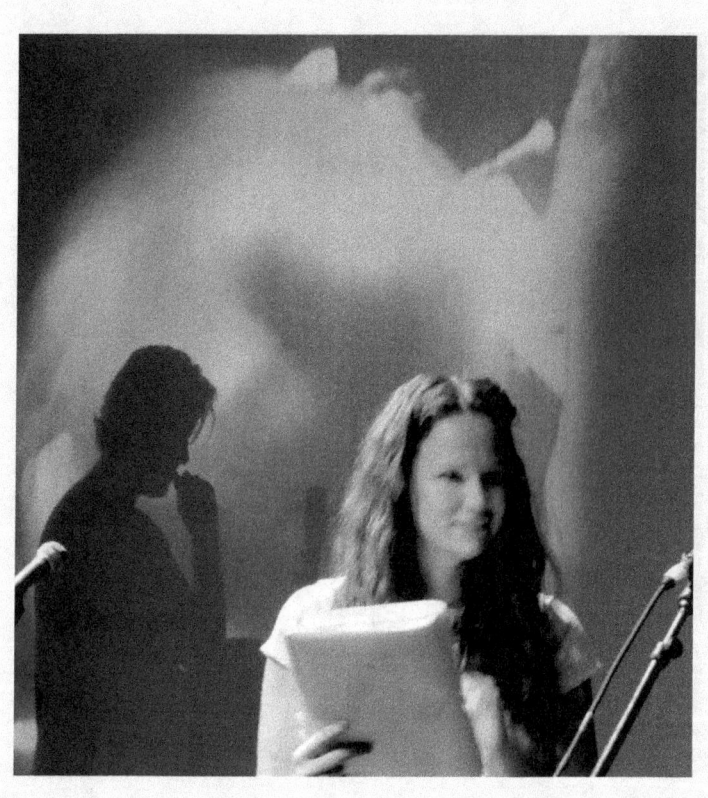

THE WILD HUNT AND THE CREATIVE PROCESS

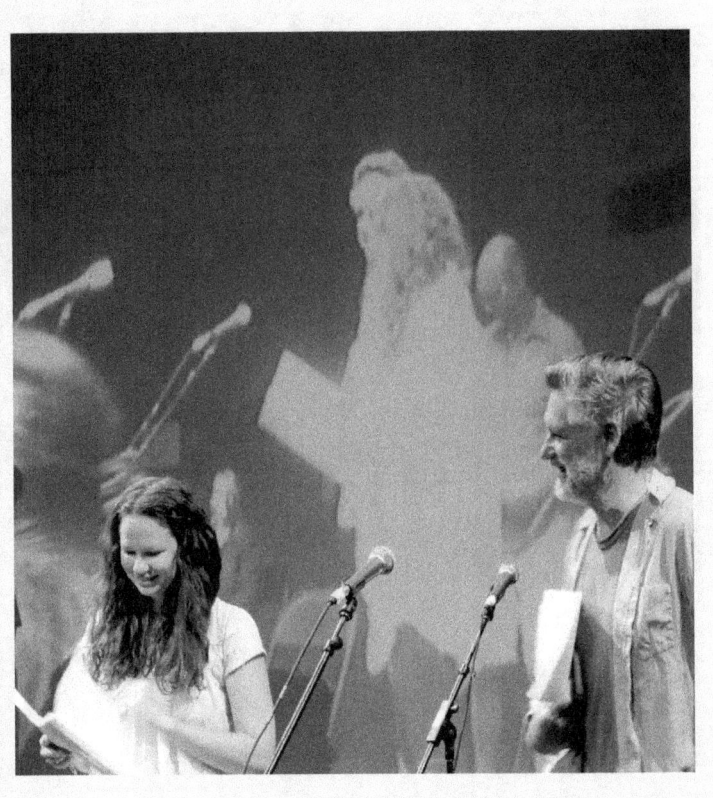

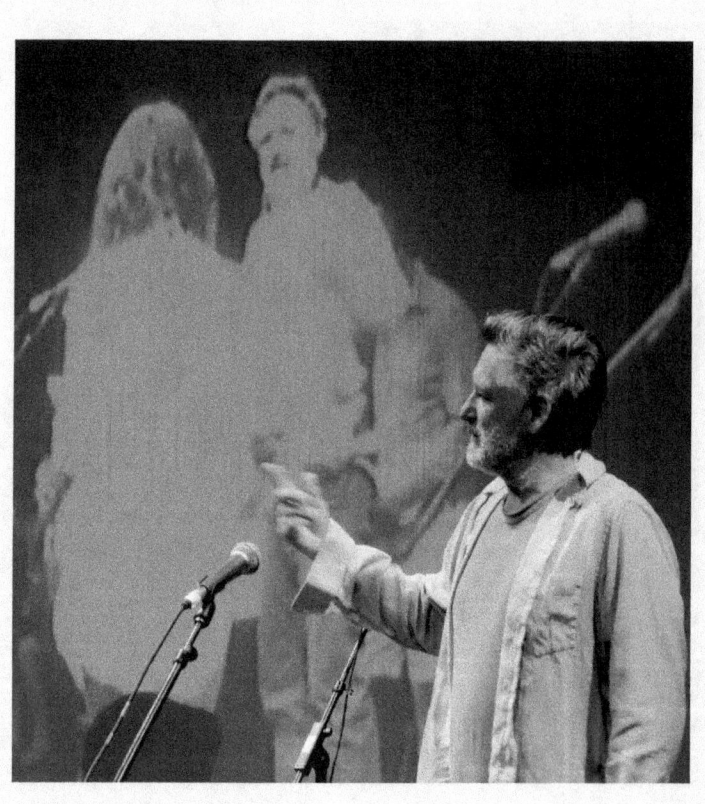

THE WILD HUNT AND THE CREATIVE PROCESS

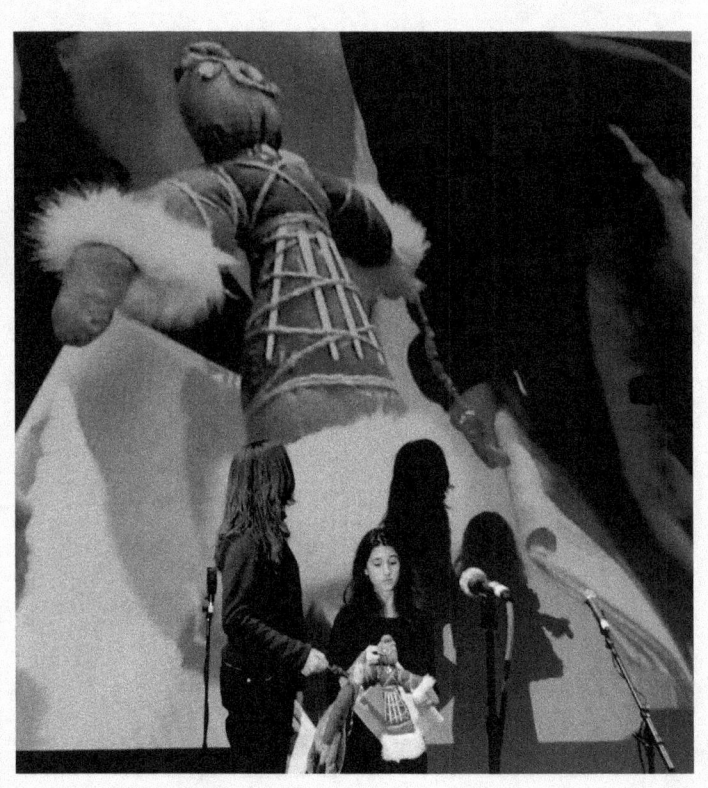

THE WILD HUNT AND THE CREATIVE PROCESS

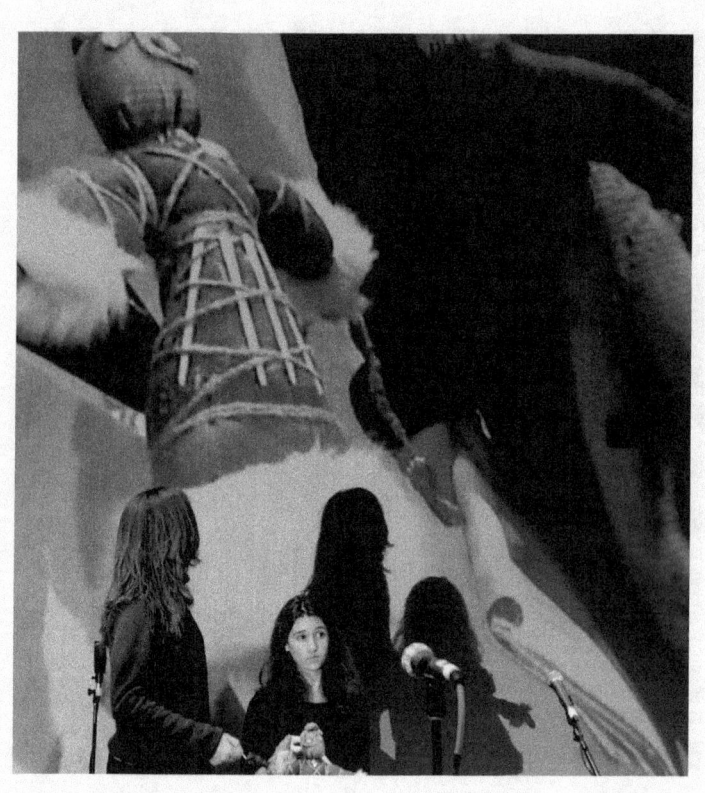

THE WILD HUNT AND THE CREATIVE PROCESS

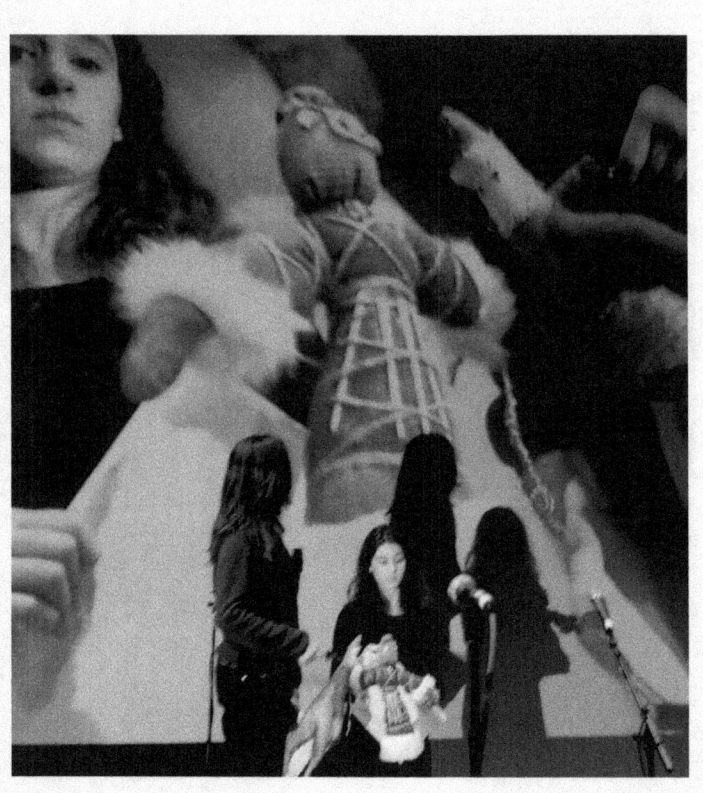

THE WILD HUNT AND THE CREATIVE PROCESS

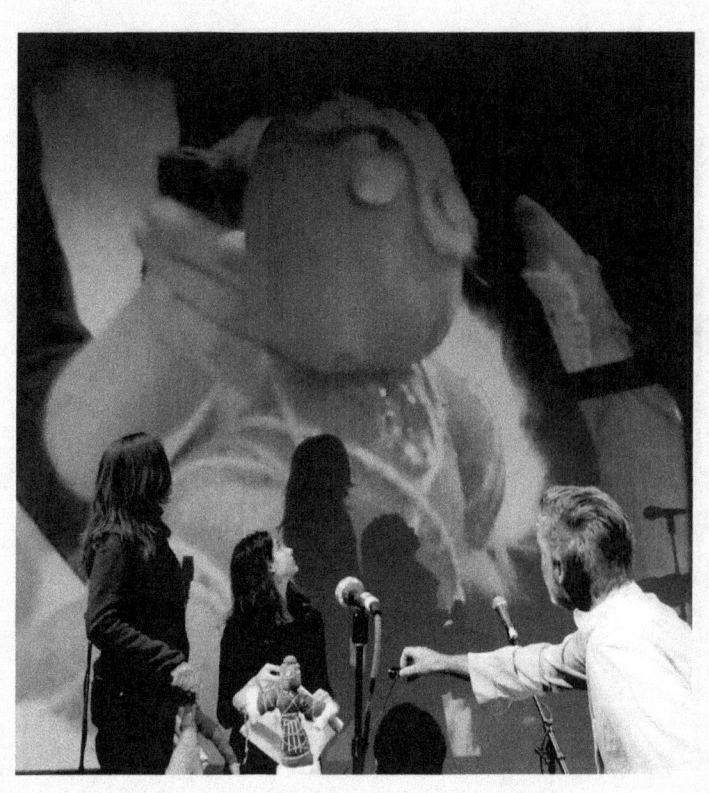

THE WILD HUNT AND THE CREATIVE PROCESS

THE WILD HUNT AND THE CREATIVE PROCESS

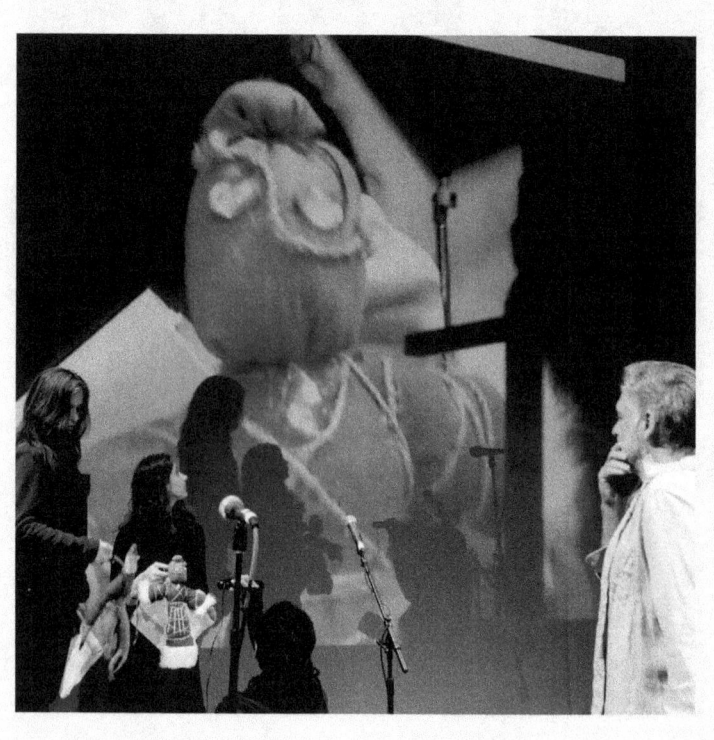

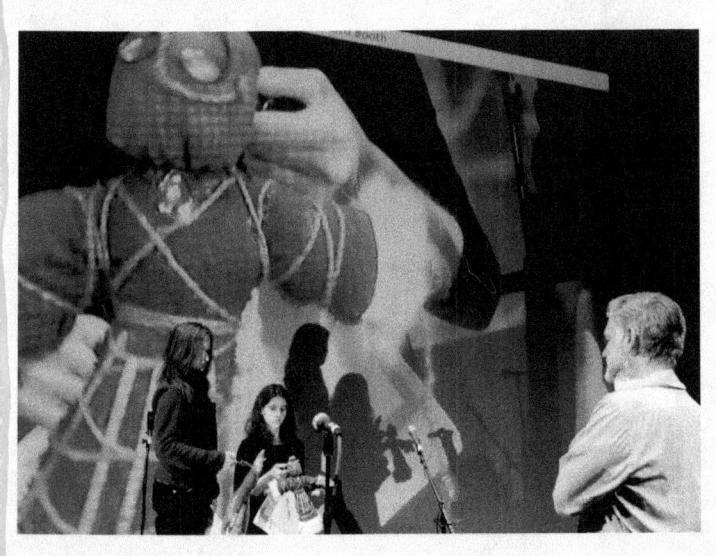

THE WILD HUNT AND THE CREATIVE PROCESS

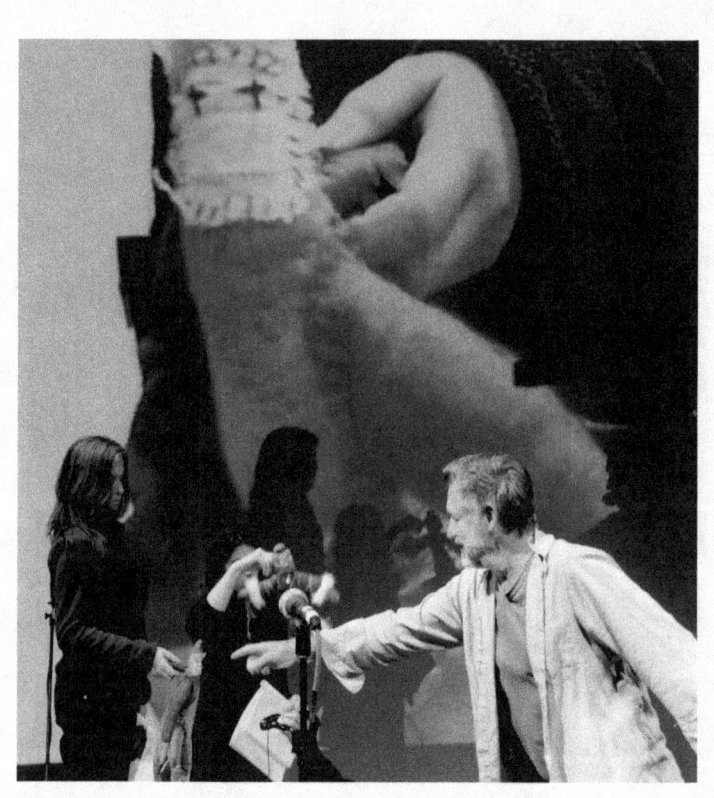

THE WILD HUNT AND THE CREATIVE PROCESS

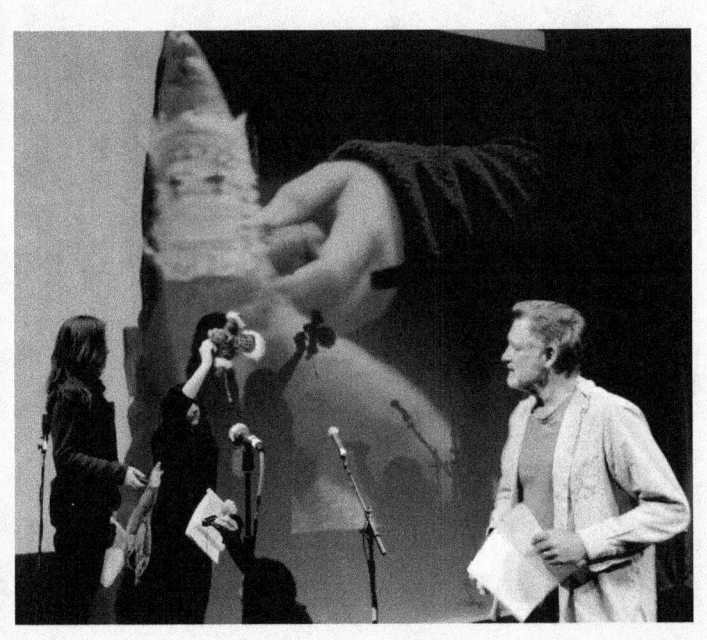

THE WILD HUNT AND THE CREATIVE PROCESS

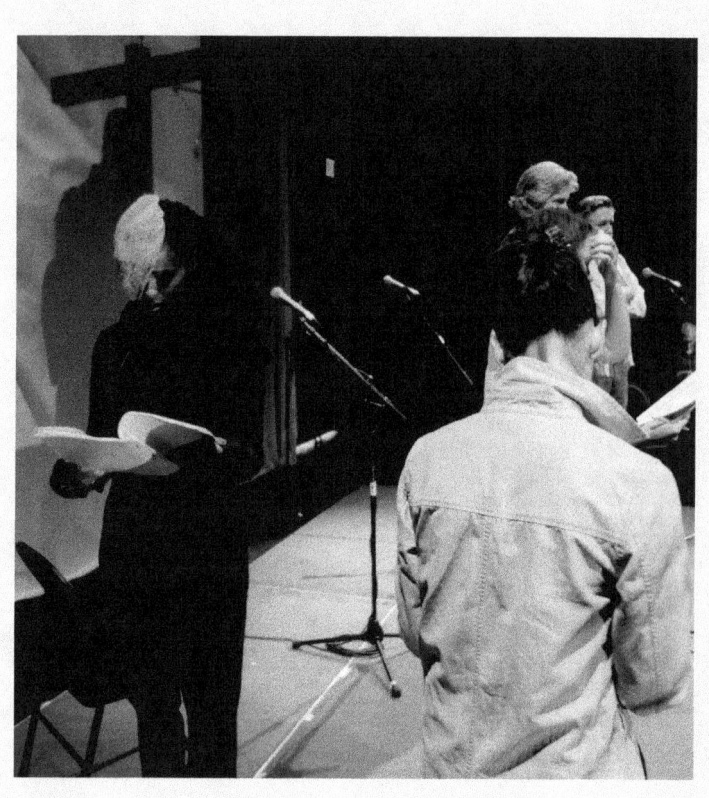

THE WILD HUNT AND THE CREATIVE PROCESS

THE WILD HUNT AND THE CREATIVE PROCESS

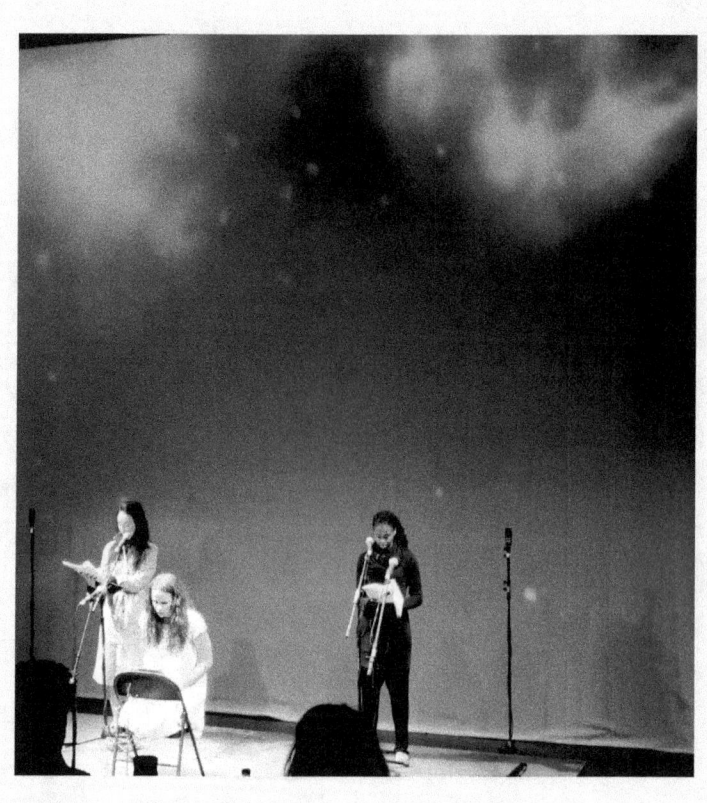

THE WILD HUNT AND THE CREATIVE PROCESS

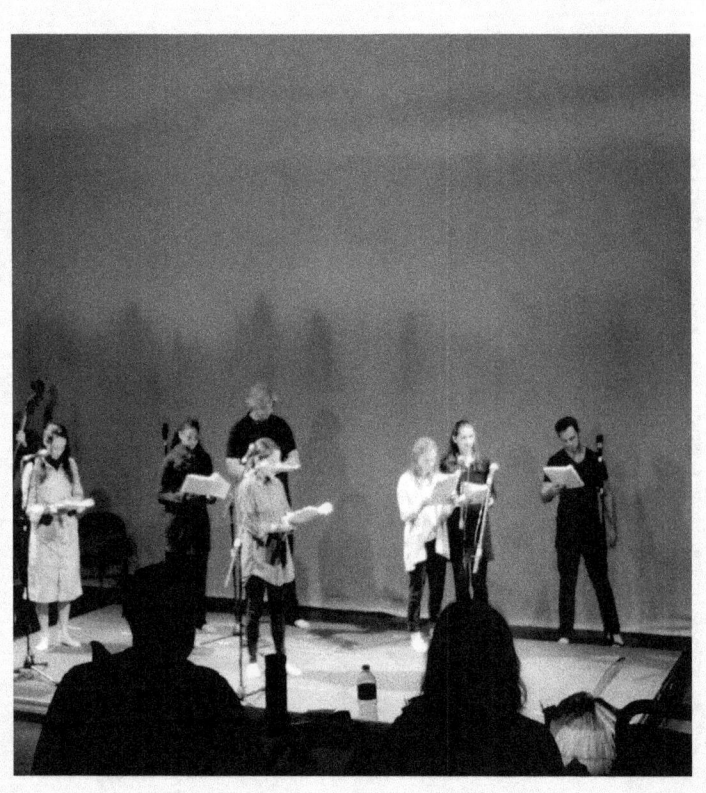

THE WILD HUNT AND THE CREATIVE PROCESS

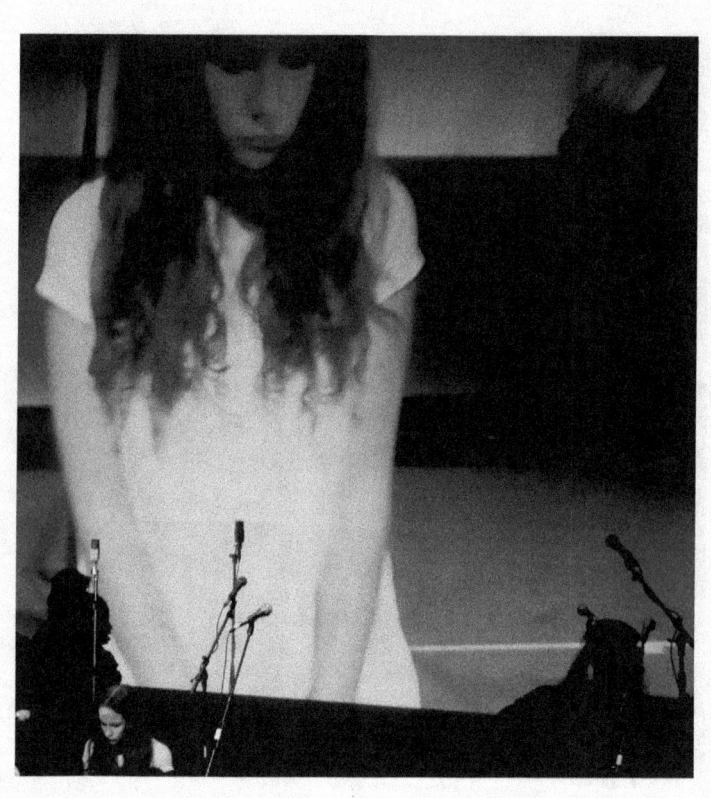

THE WILD HUNT AND THE CREATIVE PROCESS

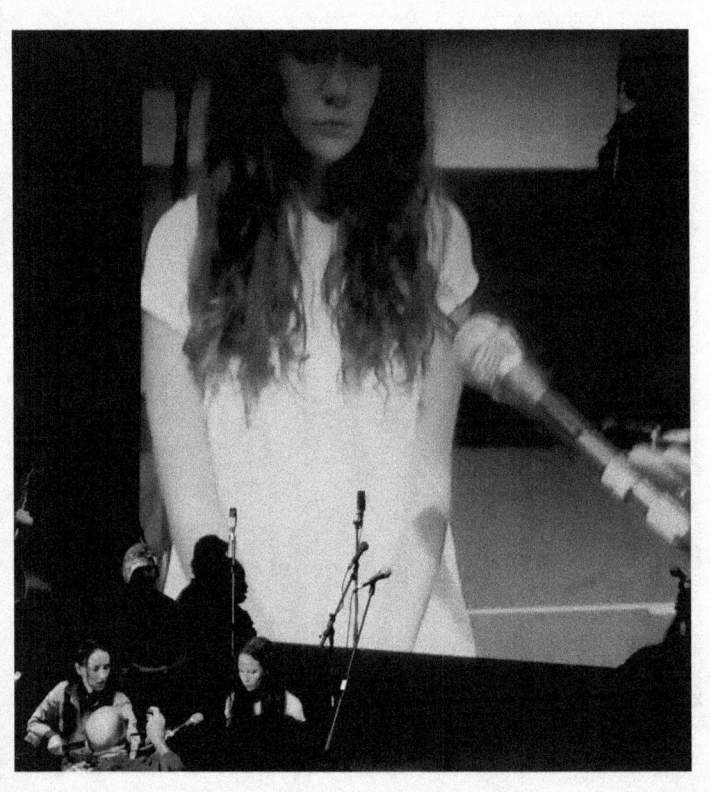

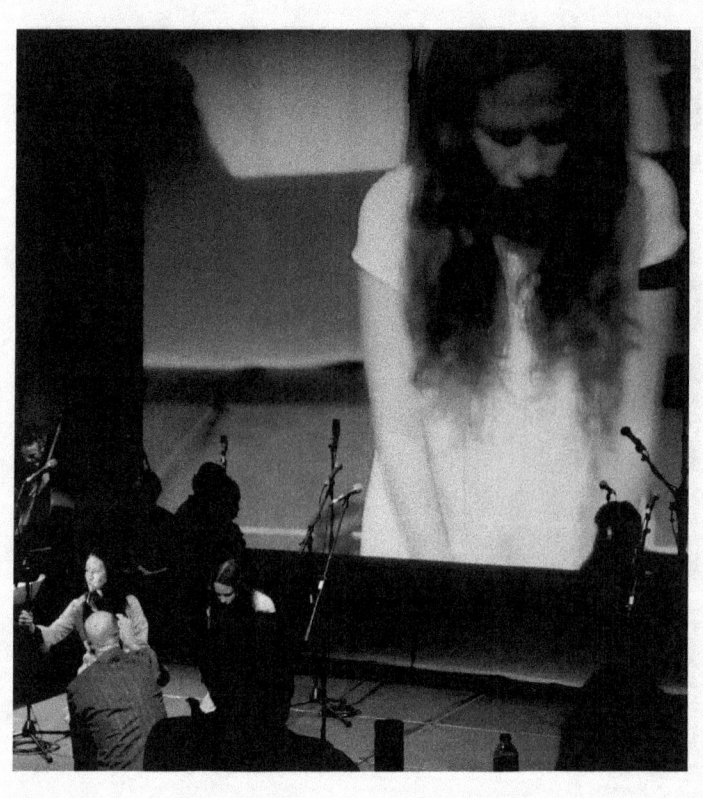

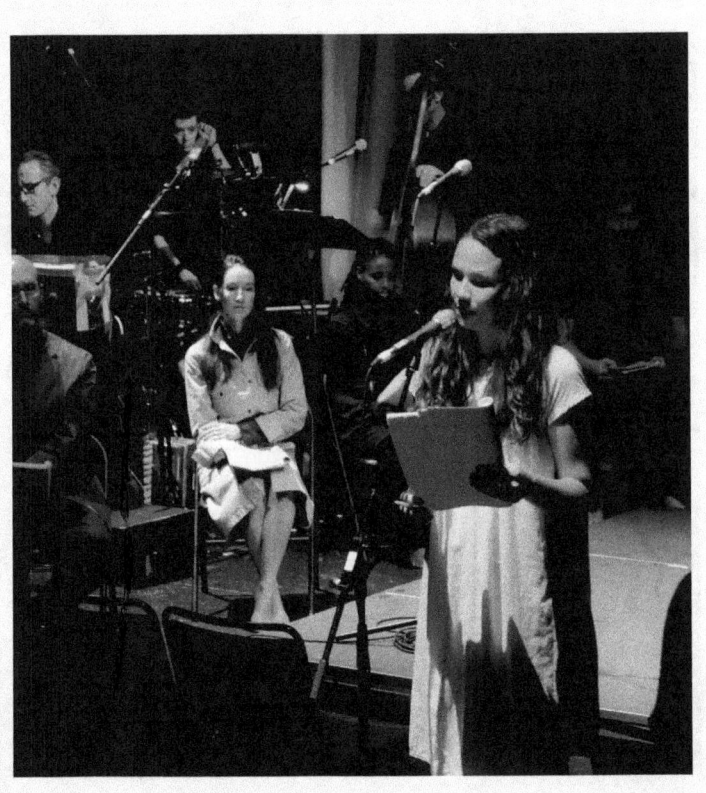

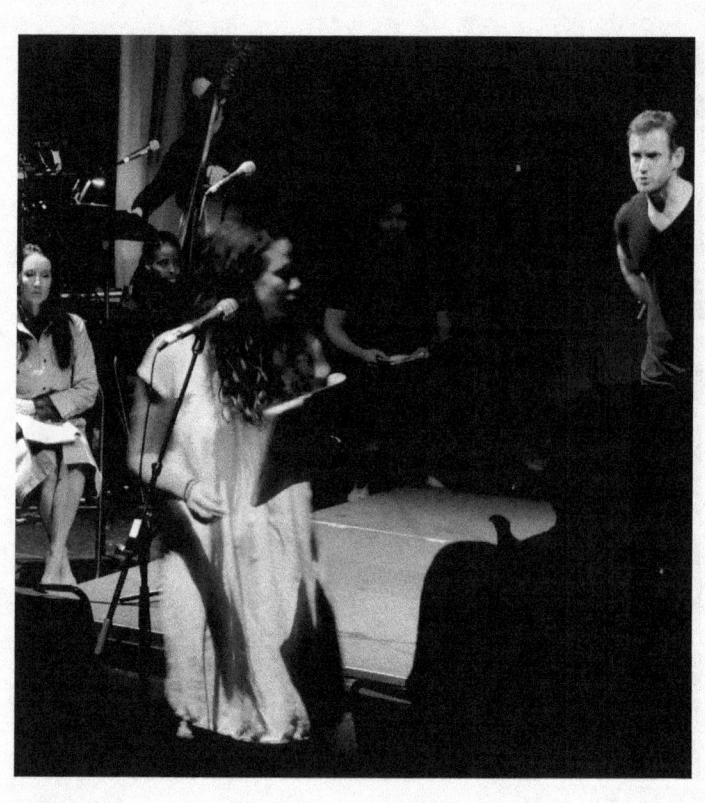

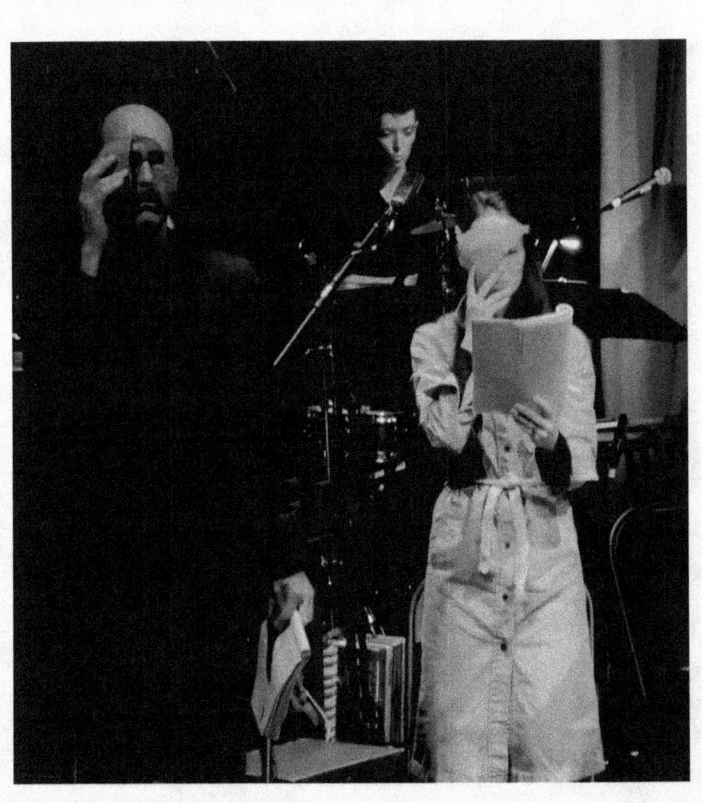

THE WILD HUNT AND THE CREATIVE PROCESS

THE WILD HUNT AND THE CREATIVE PROCESS

THE WILD HUNT AND THE CREATIVE PROCESS

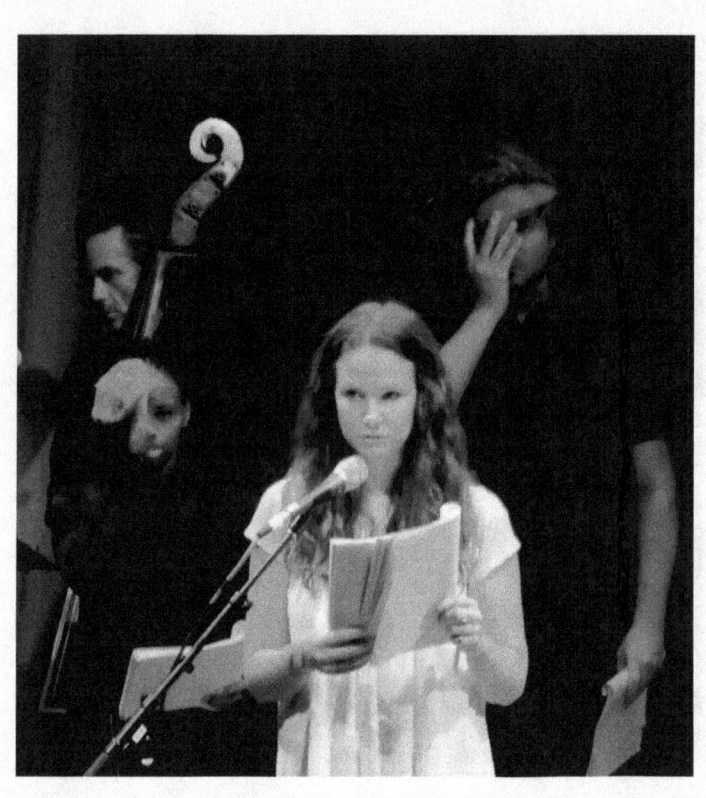

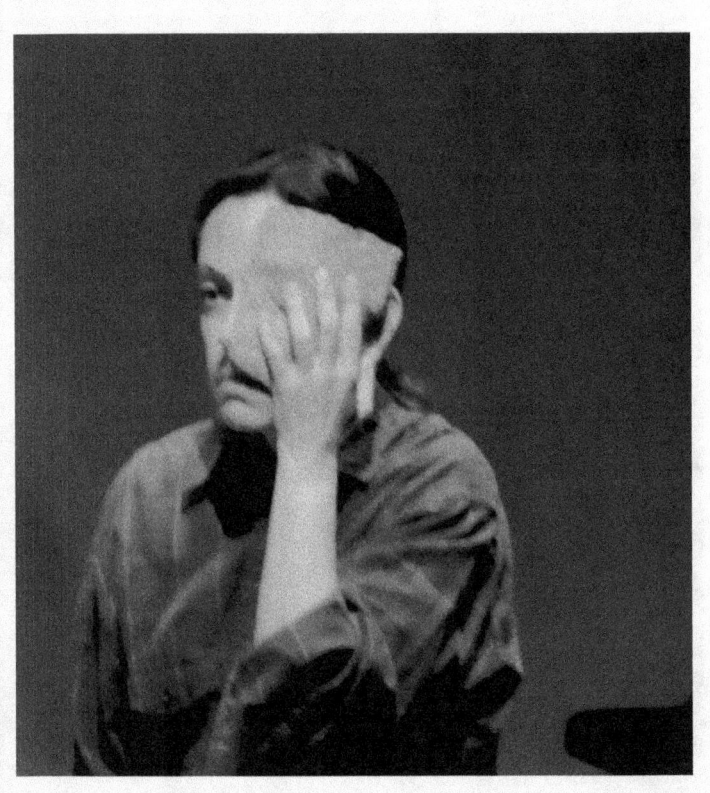

THE WILD HUNT AND THE CREATIVE PROCESS

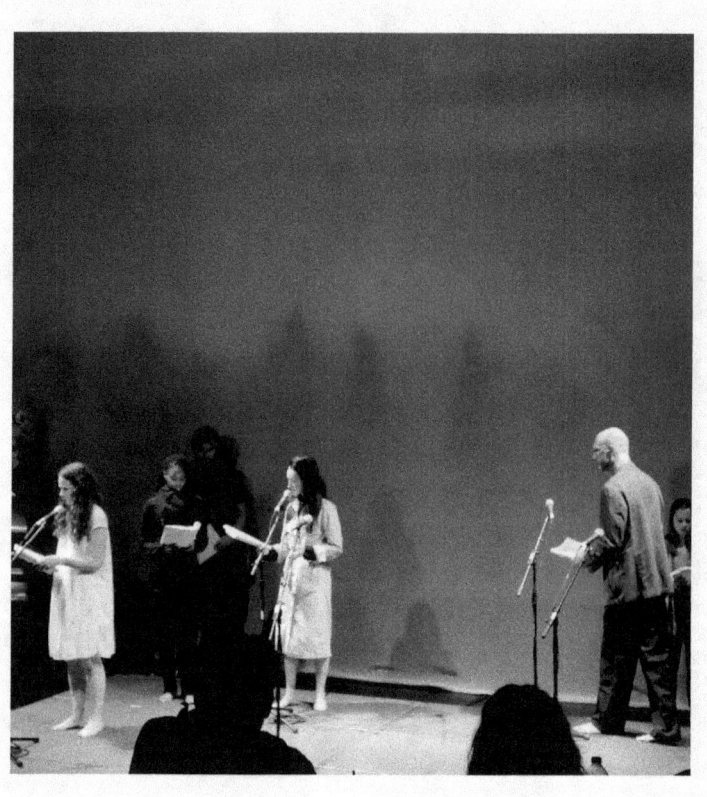

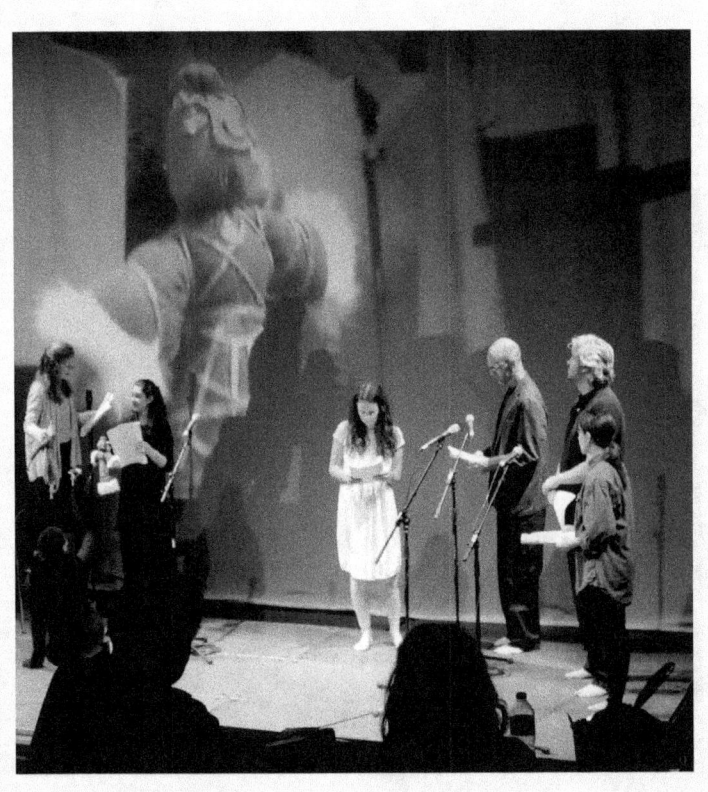

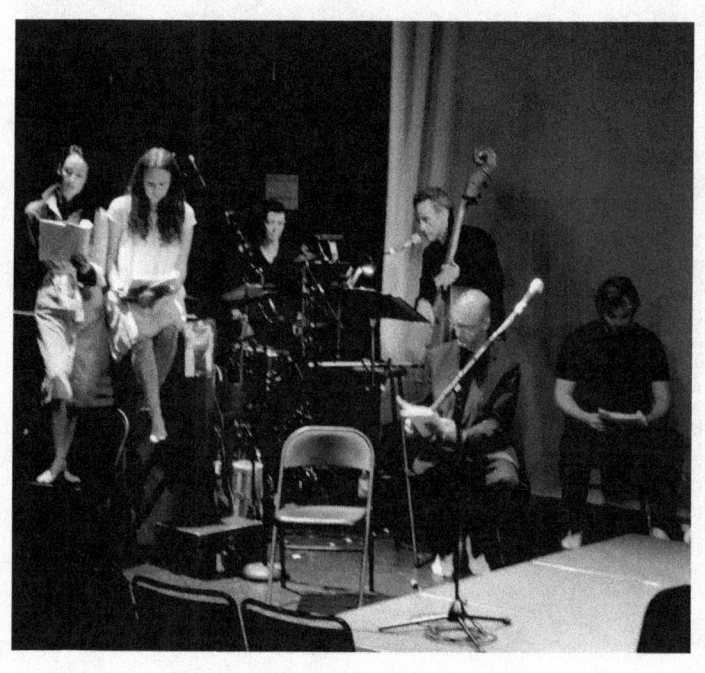

THE WILD HUNT AND THE CREATIVE PROCESS

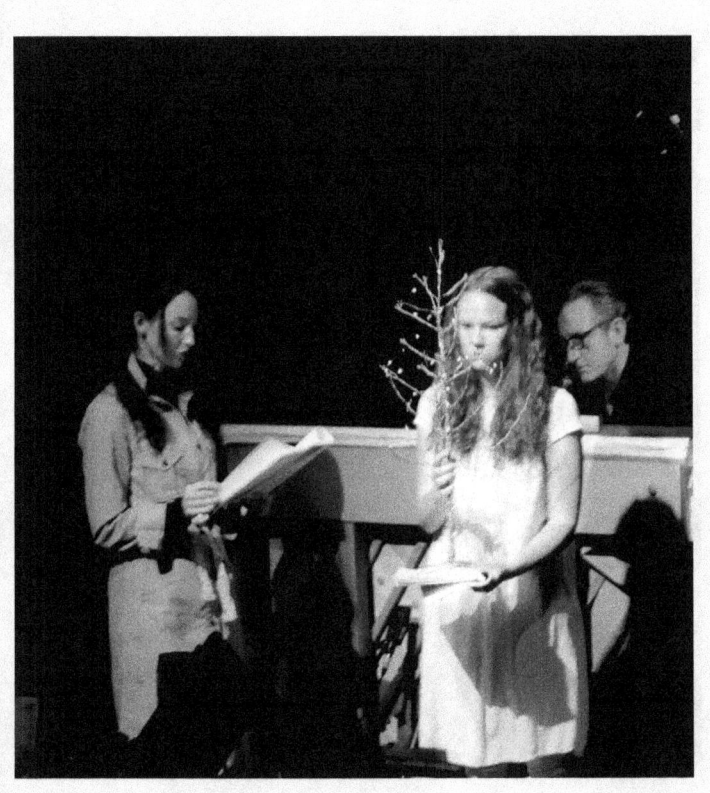

THE WILD HUNT AND THE CREATIVE PROCESS

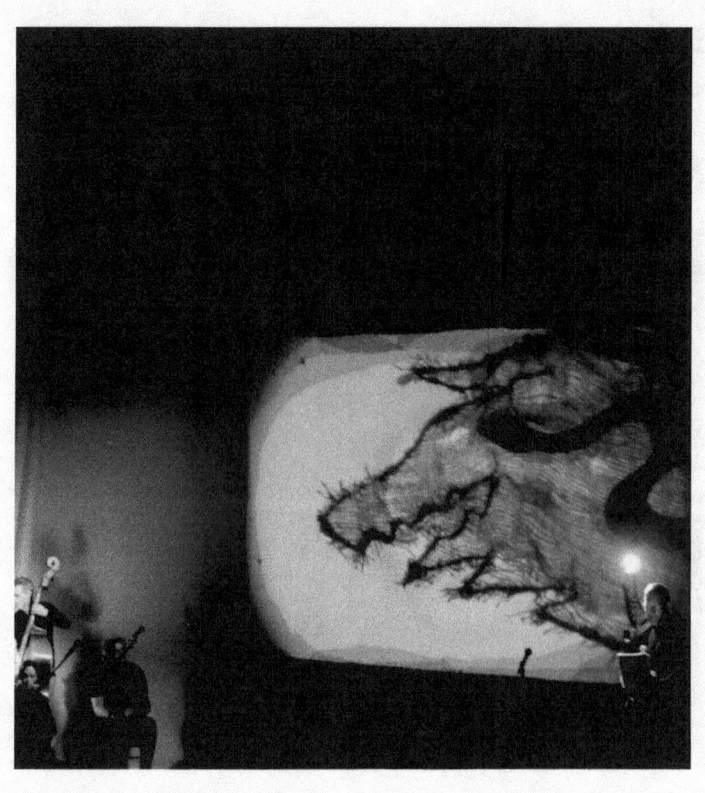

THE WILD HUNT AND THE CREATIVE PROCESS

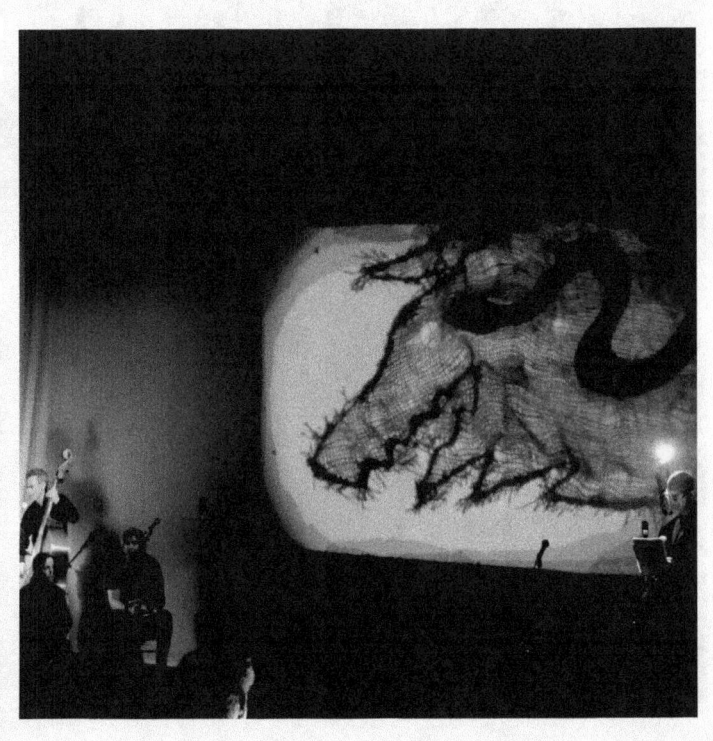

THE WILD HUNT AND THE CREATIVE PROCESS

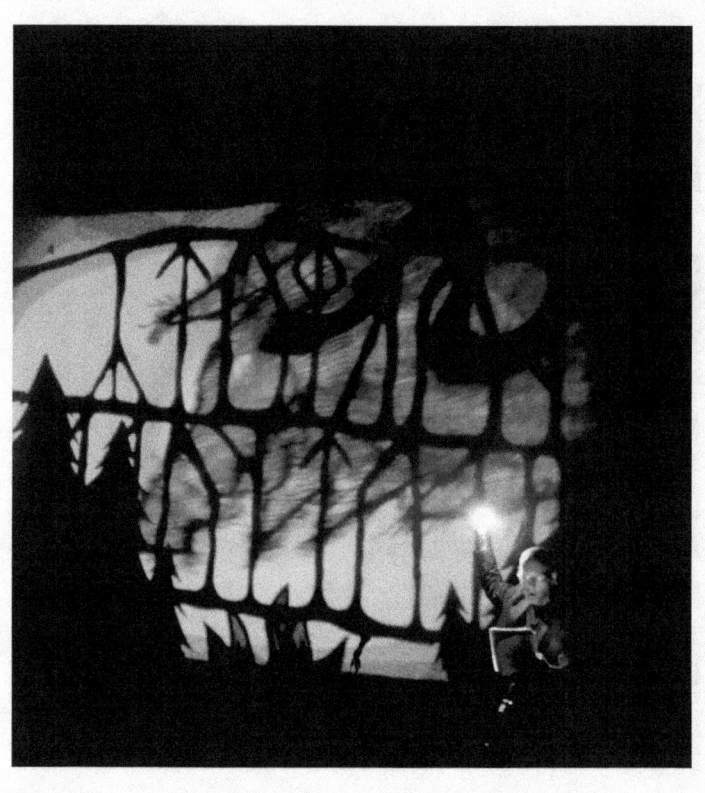

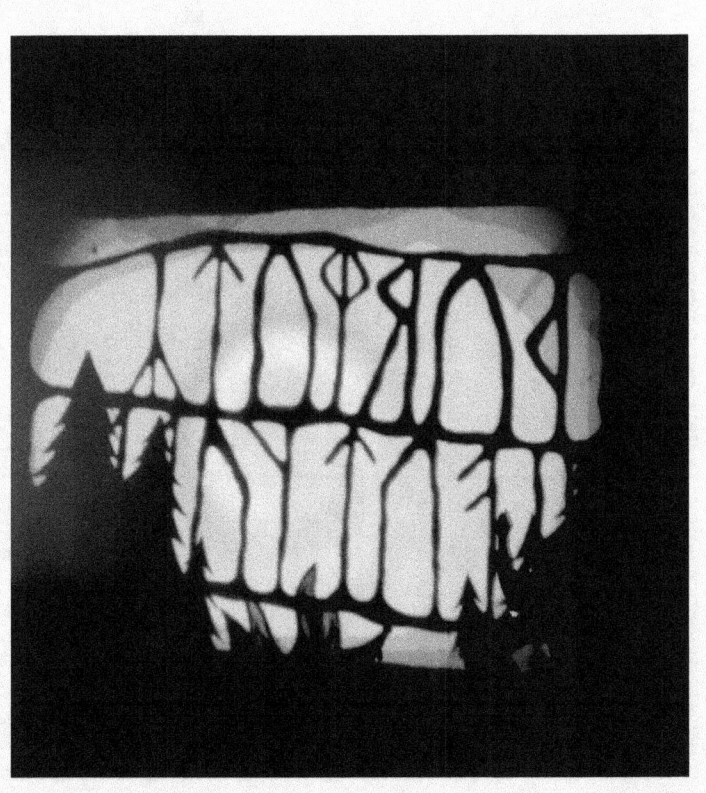

THE WILD HUNT AND THE CREATIVE PROCESS

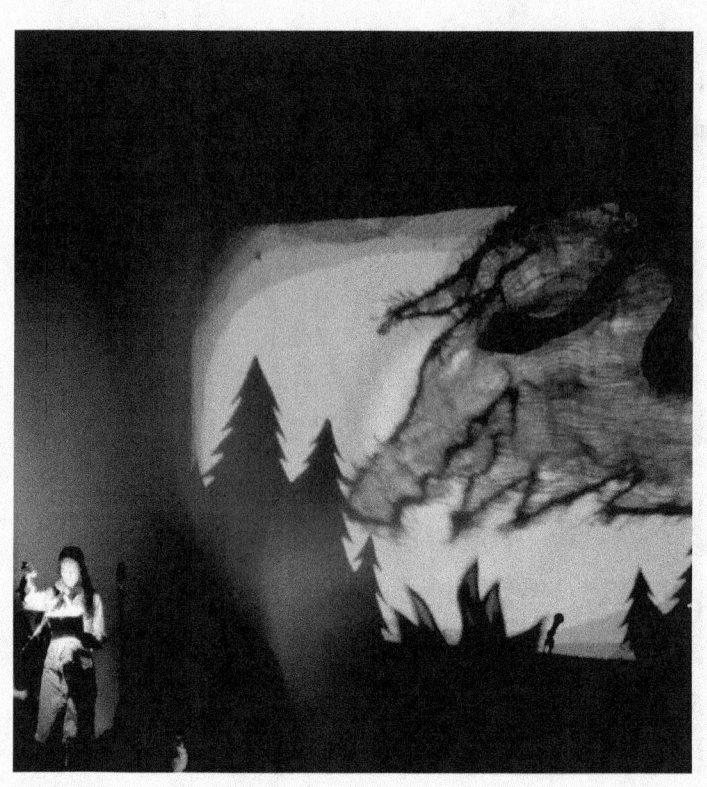

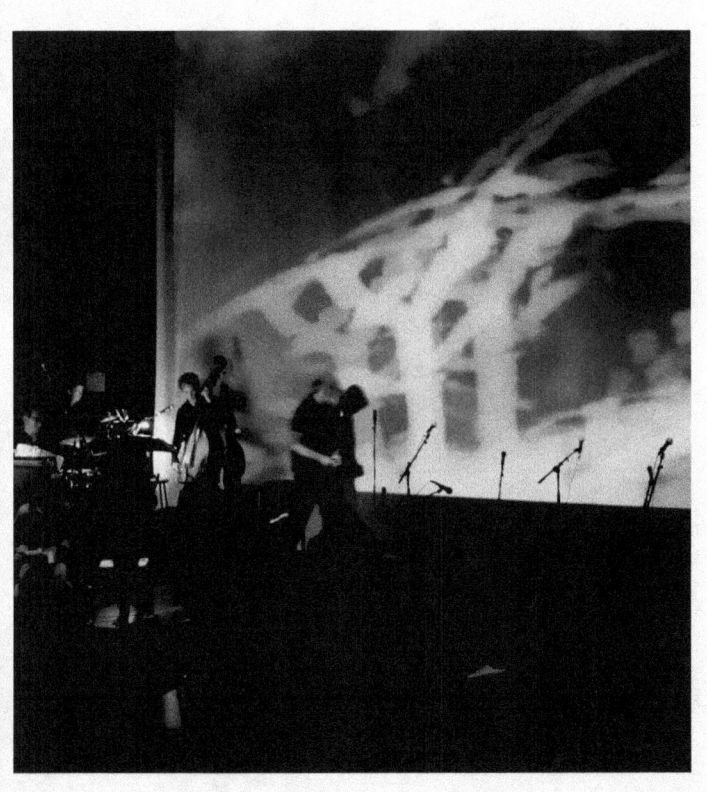

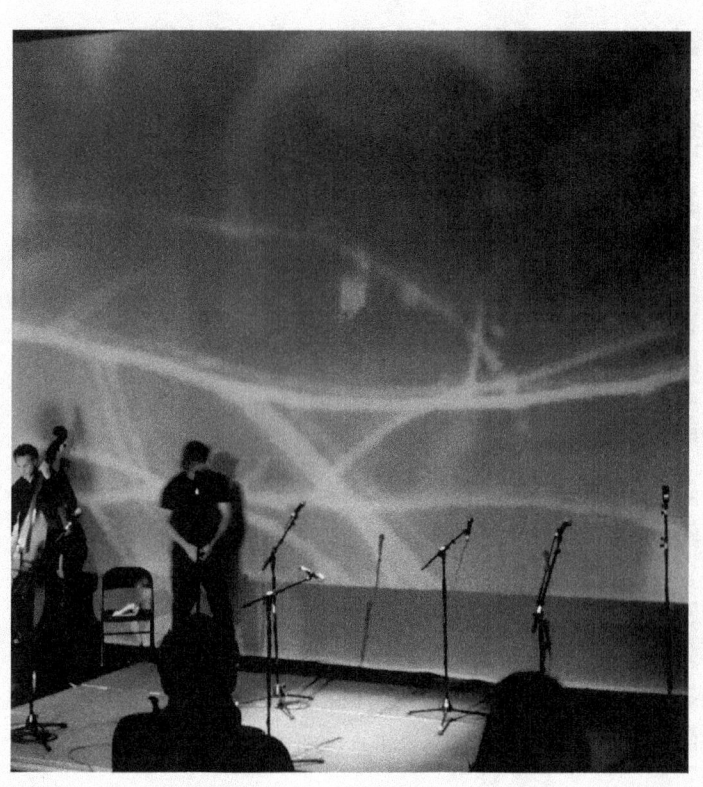

THE WILD HUNT AND THE CREATIVE PROCESS

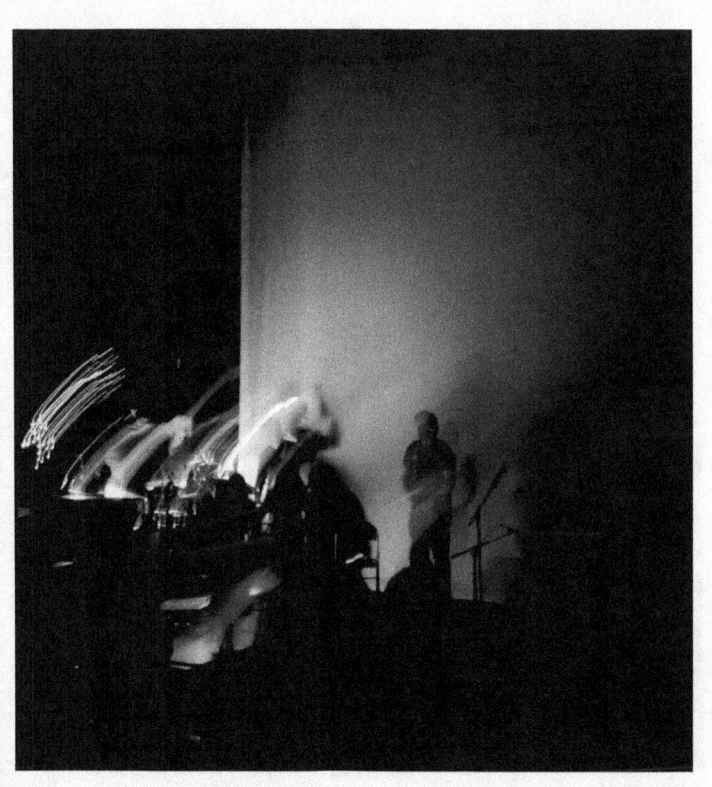

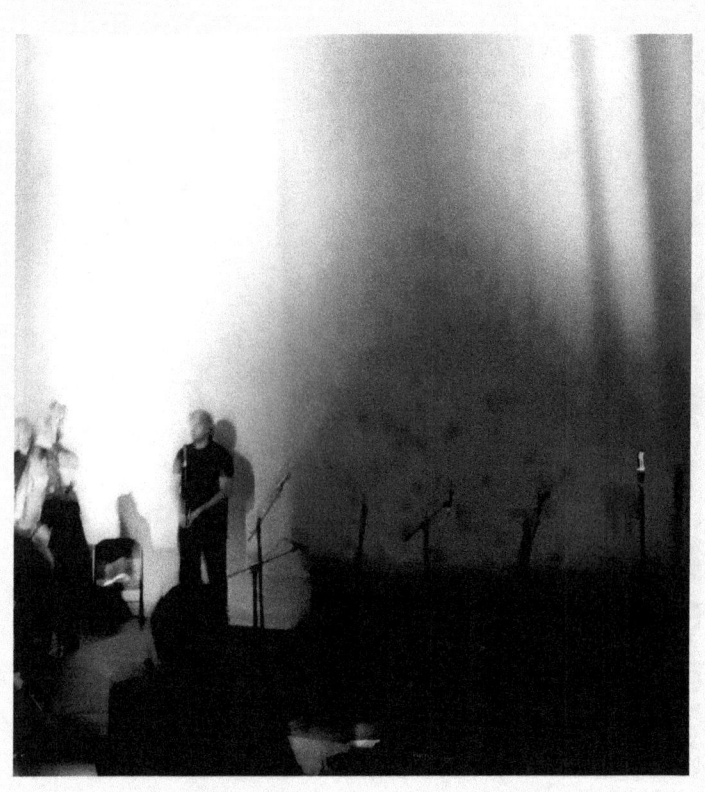

THE WILD HUNT AND THE CREATIVE PROCESS

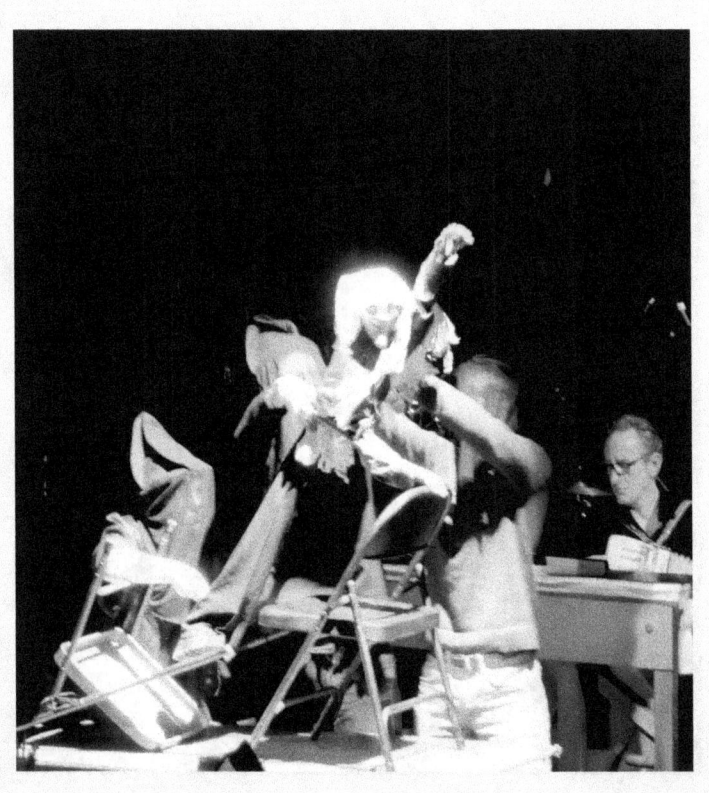

THE WILD HUNT AND THE CREATIVE PROCESS

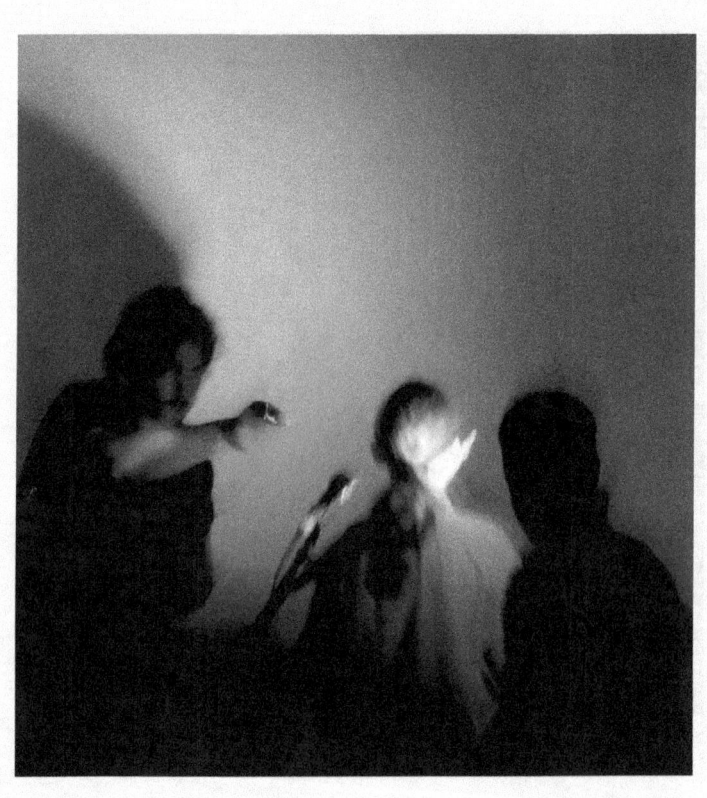

THE WILD HUNT AND THE CREATIVE PROCESS

THE WILD HUNT AND THE CREATIVE PROCESS

THE WILD HUNT AND THE CREATIVE PROCESS

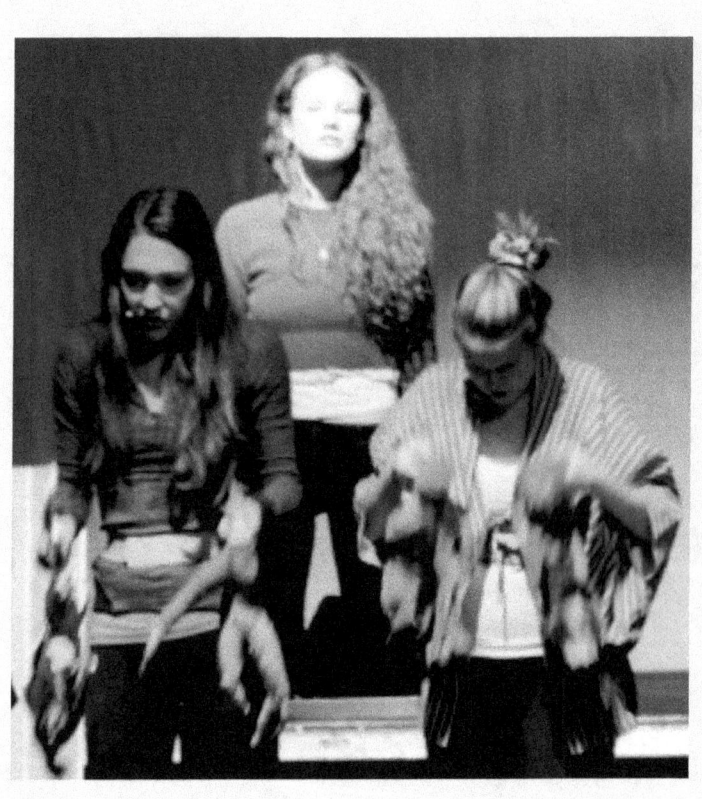

THE WILD HUNT AND THE CREATIVE PROCESS

THE WILD HUNT AND THE CREATIVE PROCESS

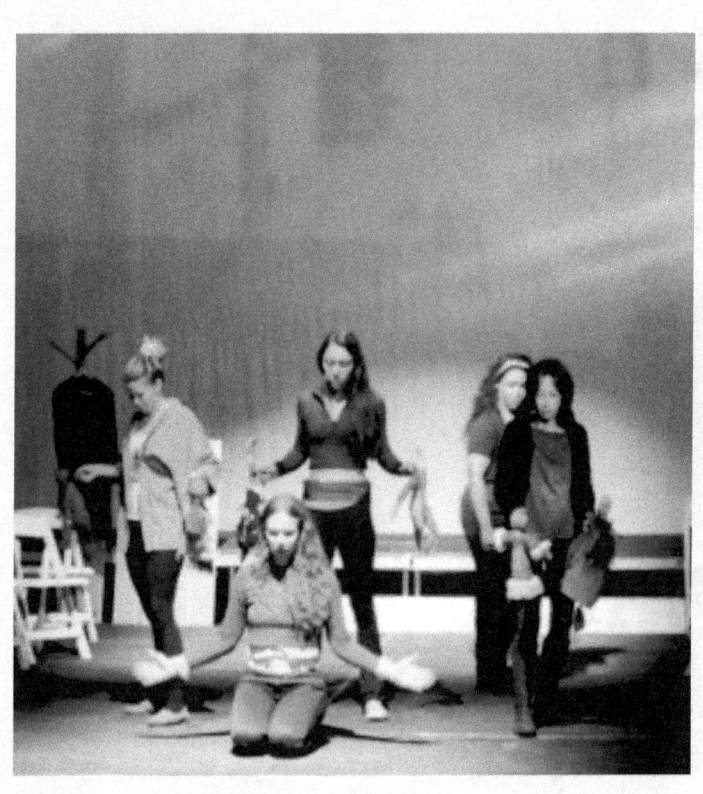

THE WILD HUNT AND THE CREATIVE PROCESS

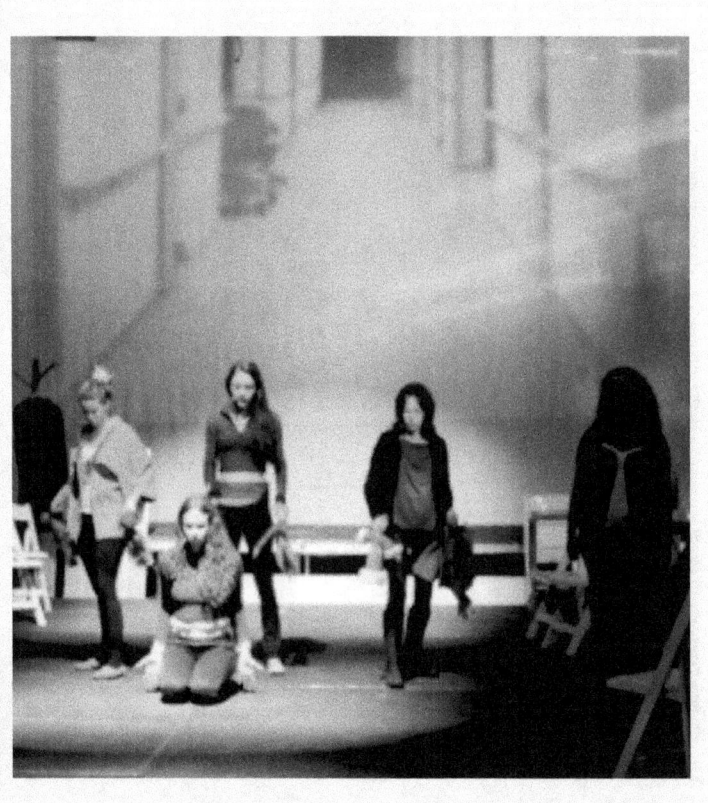

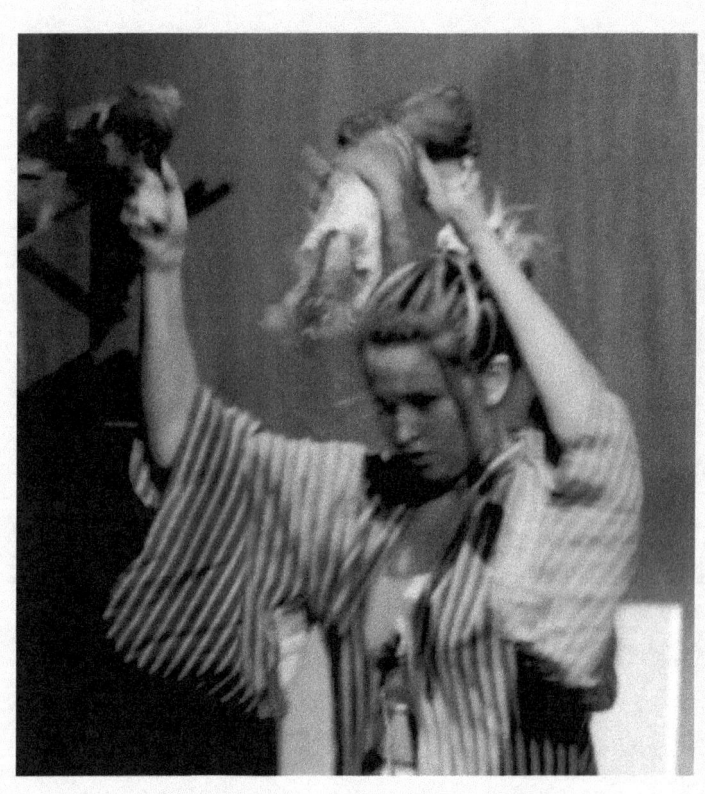

THE WILD HUNT AND THE CREATIVE PROCESS

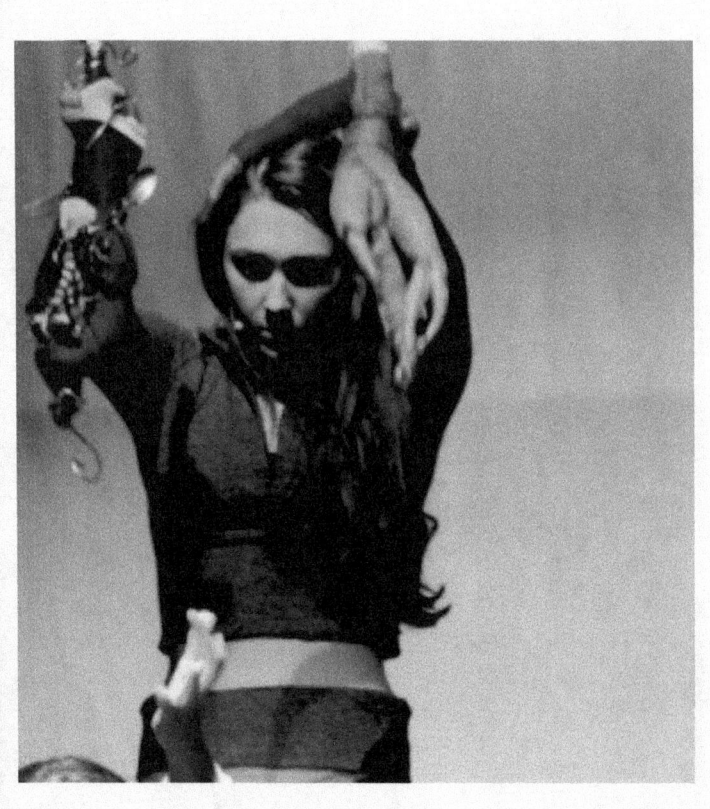

THE WILD HUNT AND THE CREATIVE PROCESS

THE WILD HUNT AND THE CREATIVE PROCESS

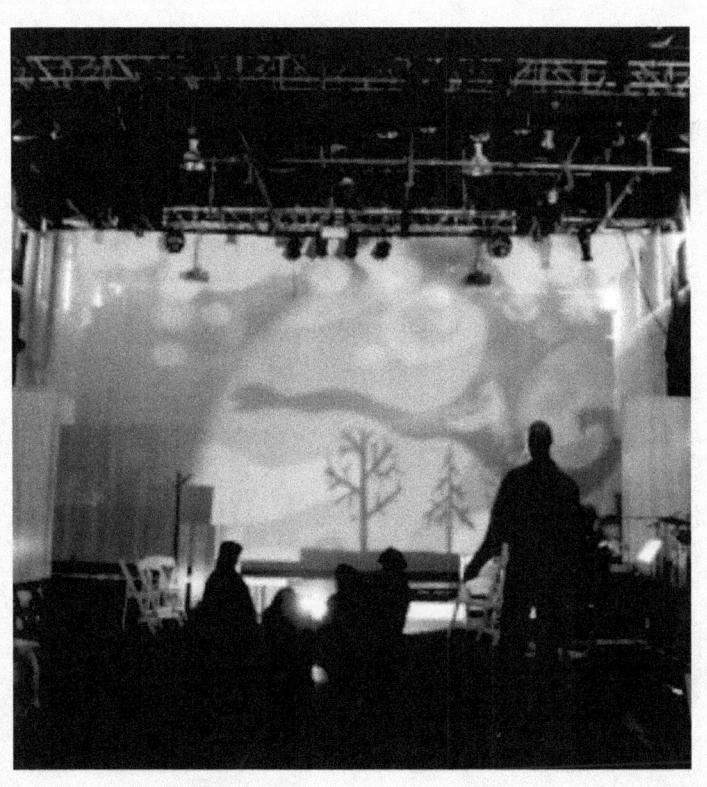

THE WILD HUNT AND THE CREATIVE PROCESS

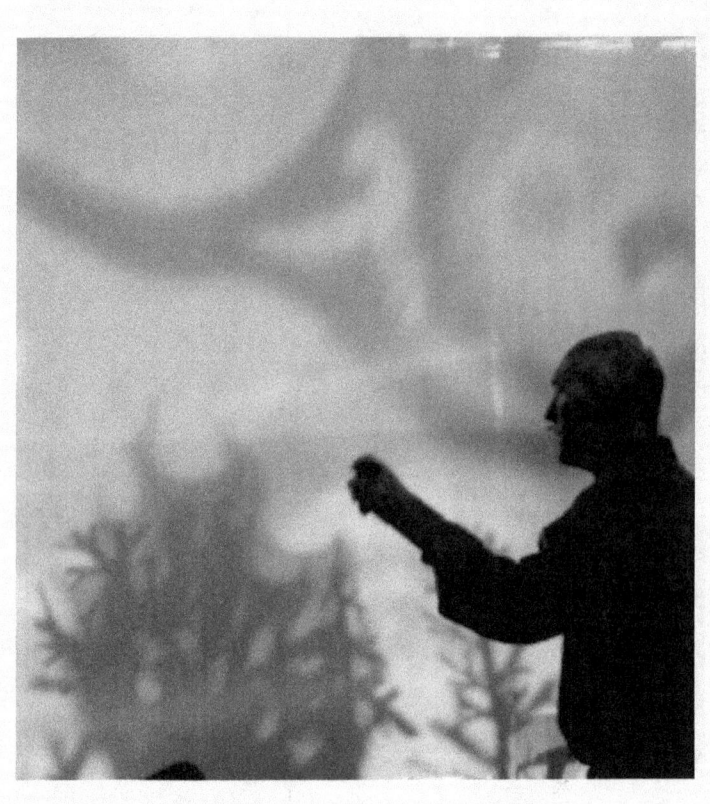

THE WILD HUNT AND THE CREATIVE PROCESS

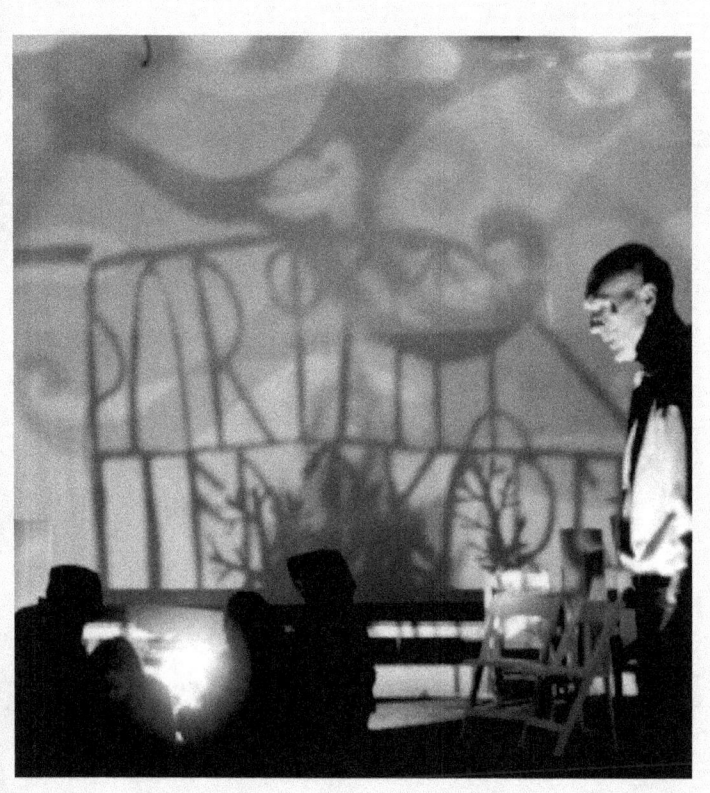

THE WILD HUNT AND THE CREATIVE PROCESS

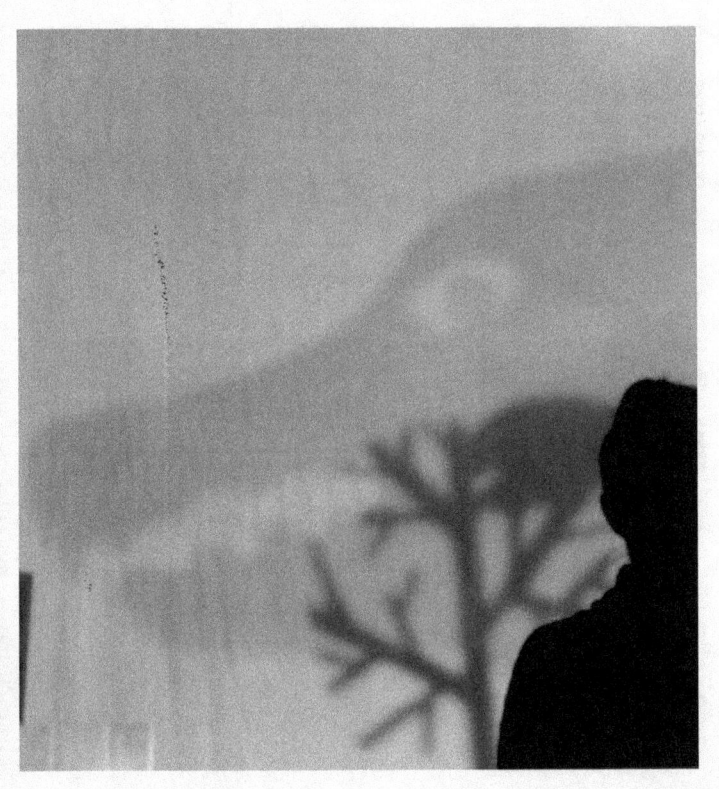

THE WILD HUNT AND THE CREATIVE PROCESS

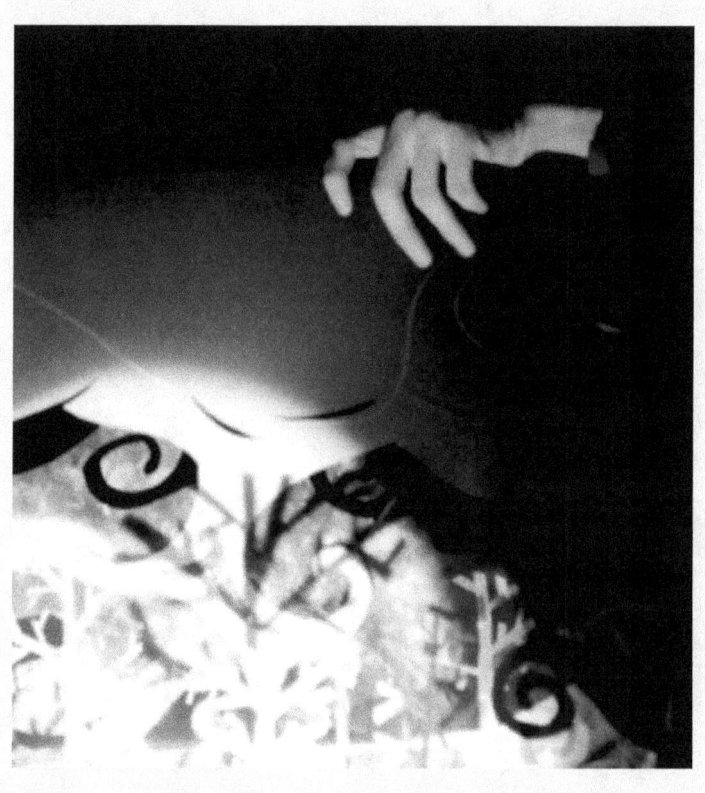

THE WILD HUNT AND THE CREATIVE PROCESS

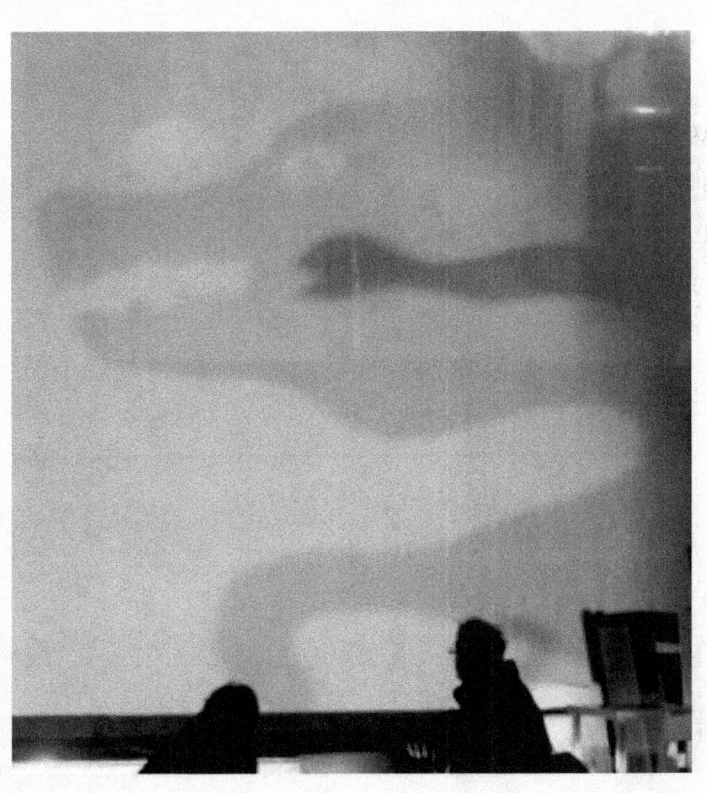

THE WILD HUNT AND THE CREATIVE PROCESS

THE WILD HUNT AND THE CREATIVE PROCESS

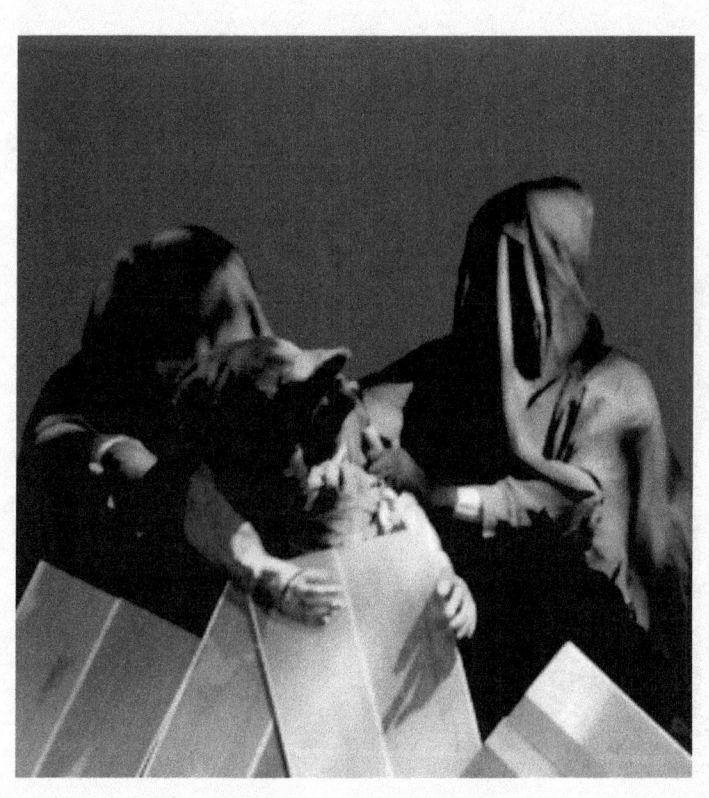

THE WILD HUNT AND THE CREATIVE PROCESS

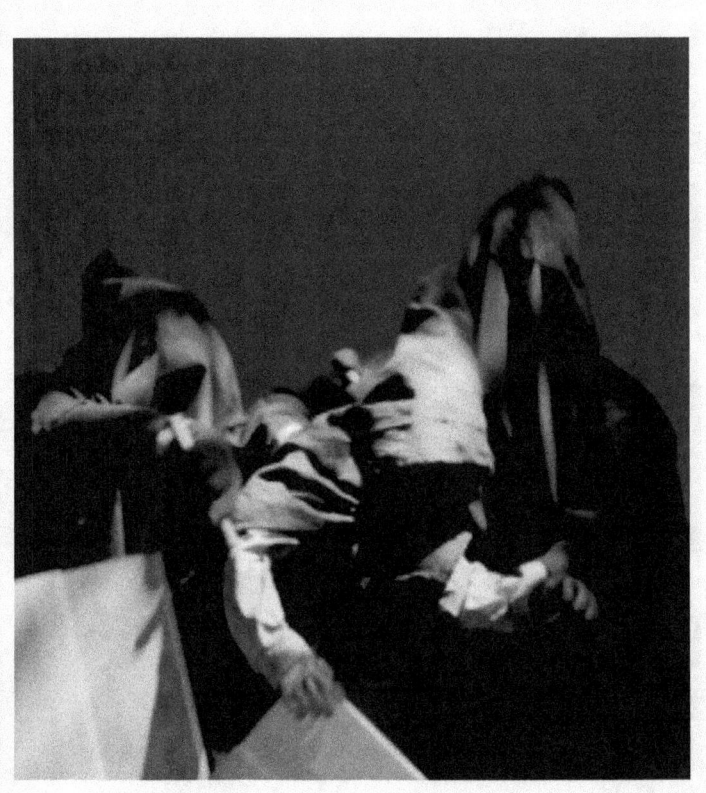

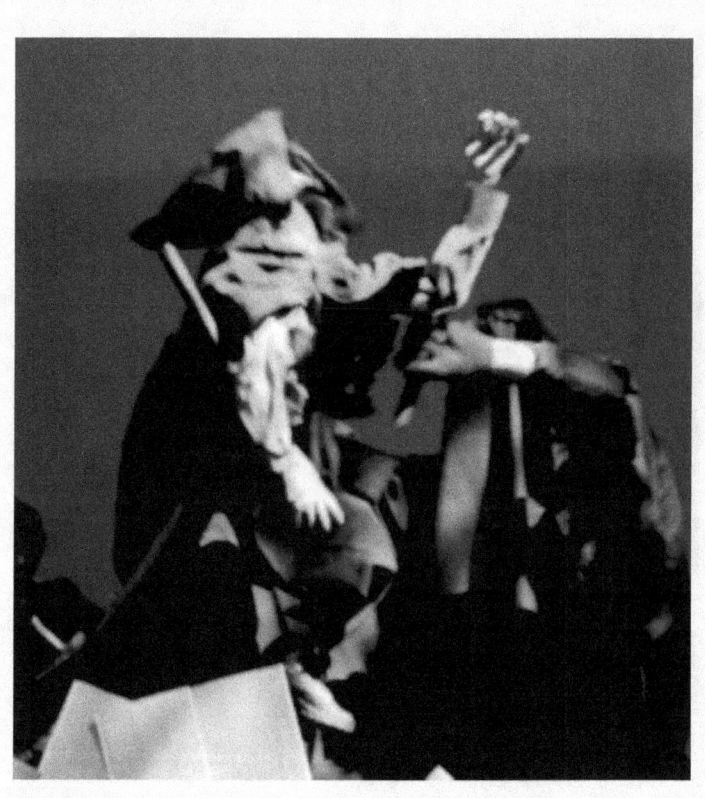

THE WILD HUNT AND THE CREATIVE PROCESS

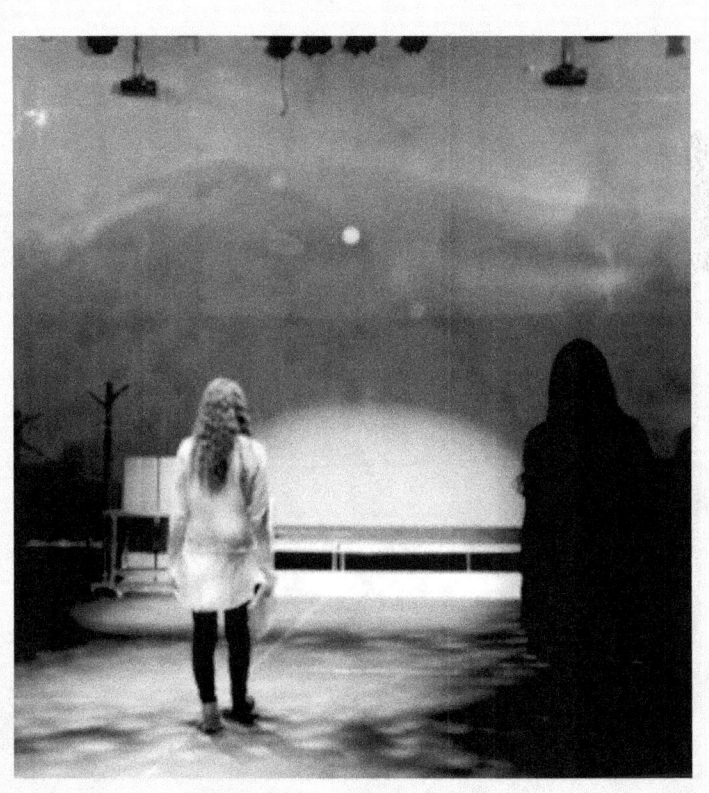

THE WILD HUNT AND THE CREATIVE PROCESS

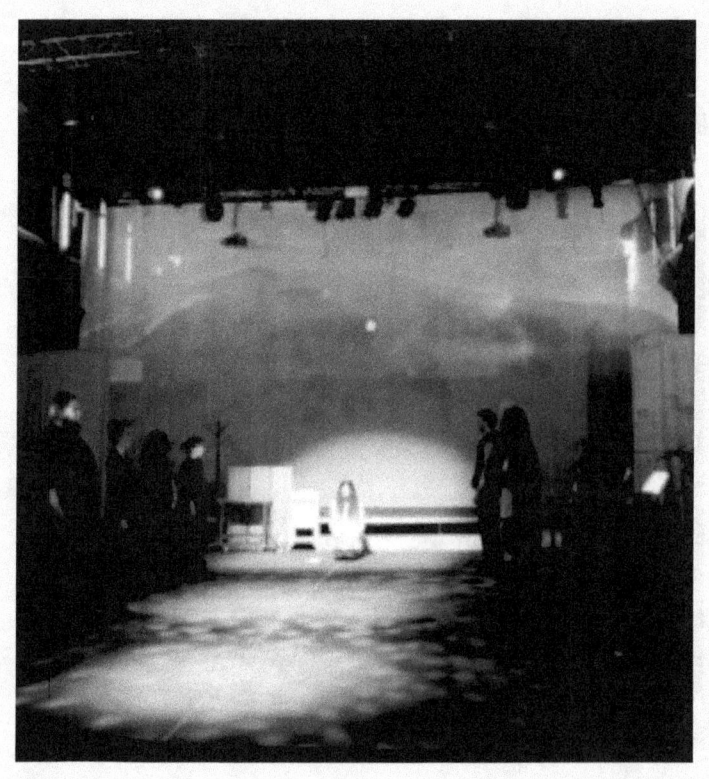

THE WILD HUNT AND THE CREATIVE PROCESS

THE WILD HUNT AND THE CREATIVE PROCESS

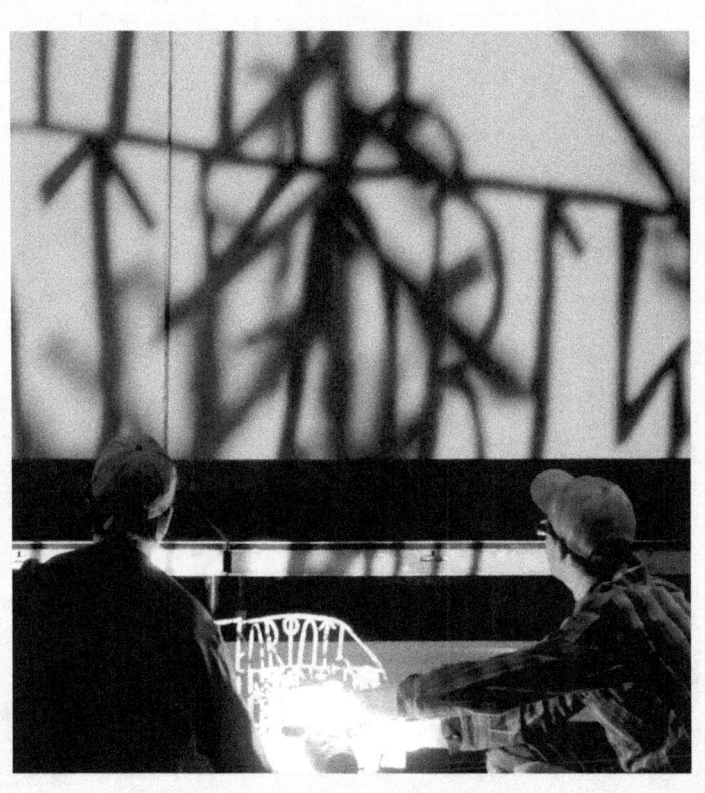

THE WILD HUNT AND THE CREATIVE PROCESS

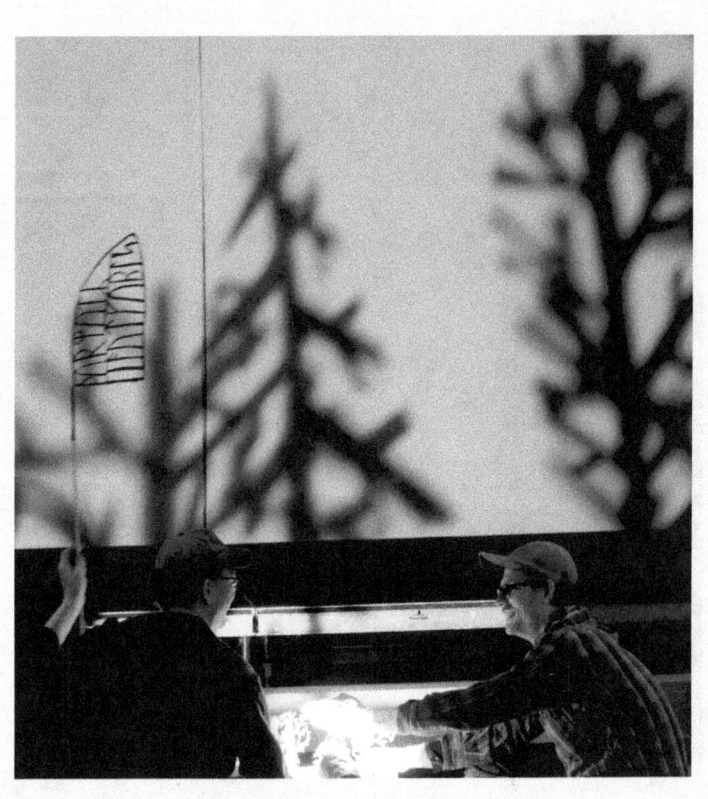

THE WILD HUNT AND THE CREATIVE PROCESS

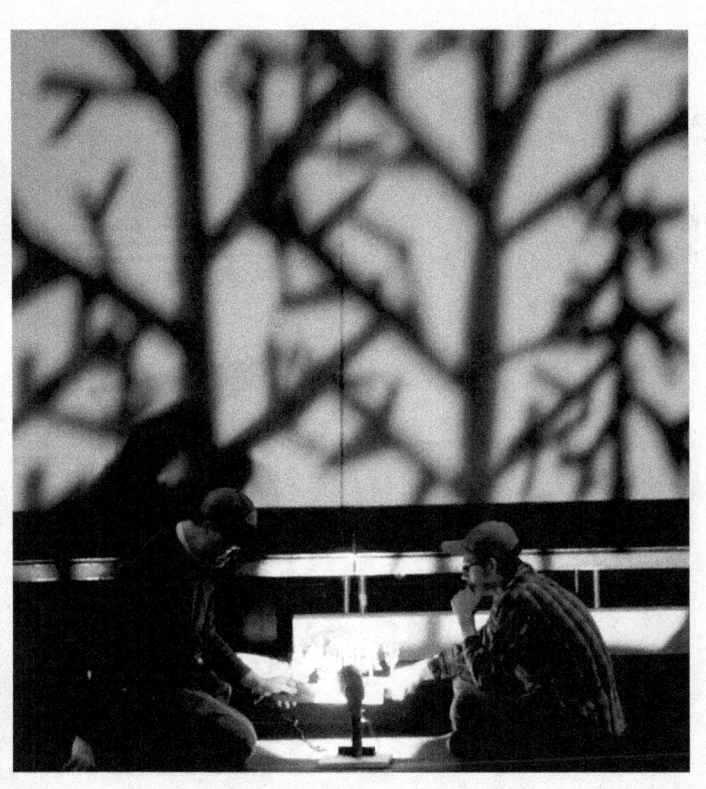

THE WILD HUNT AND THE CREATIVE PROCESS

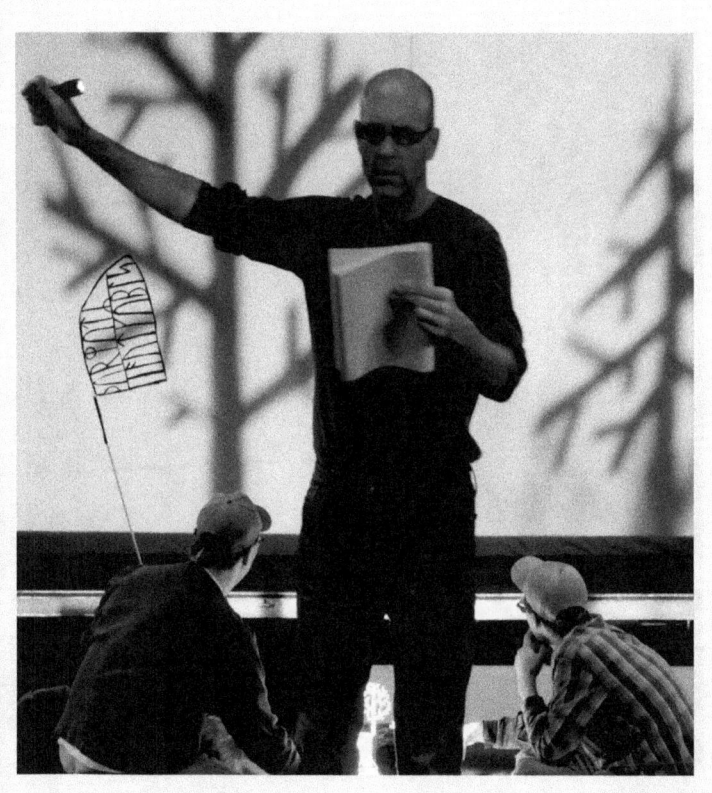

THE WILD HUNT AND THE CREATIVE PROCESS

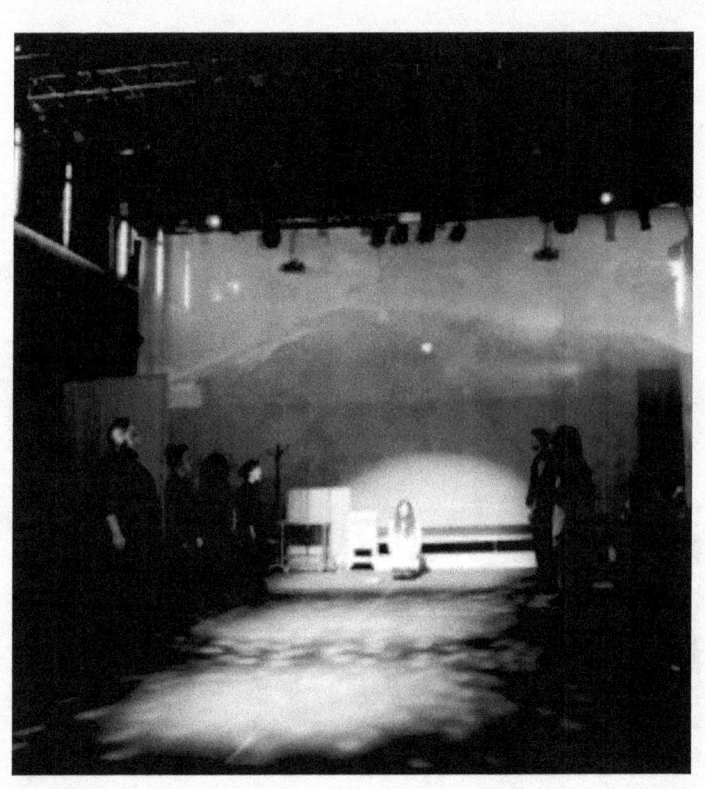

THE WILD HUNT AND THE CREATIVE PROCESS

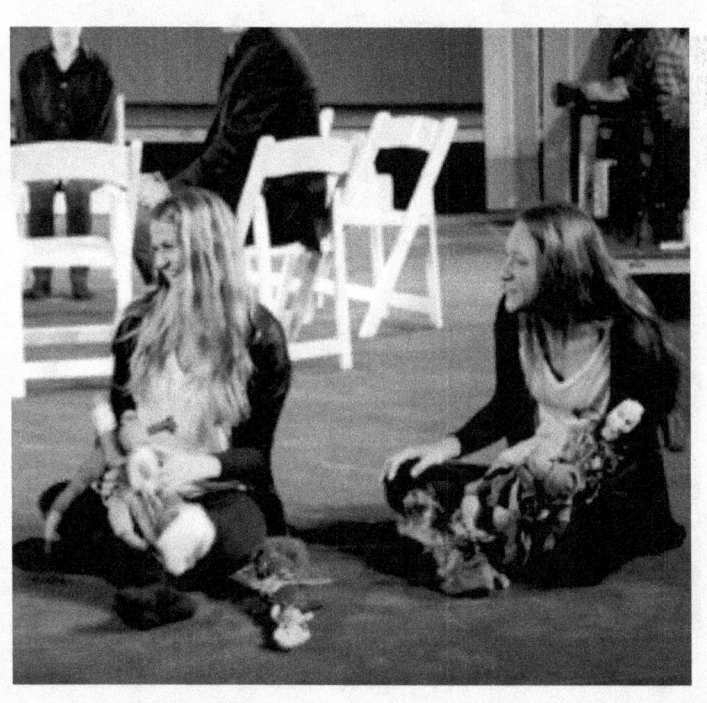

THE WILD HUNT AND THE CREATIVE PROCESS

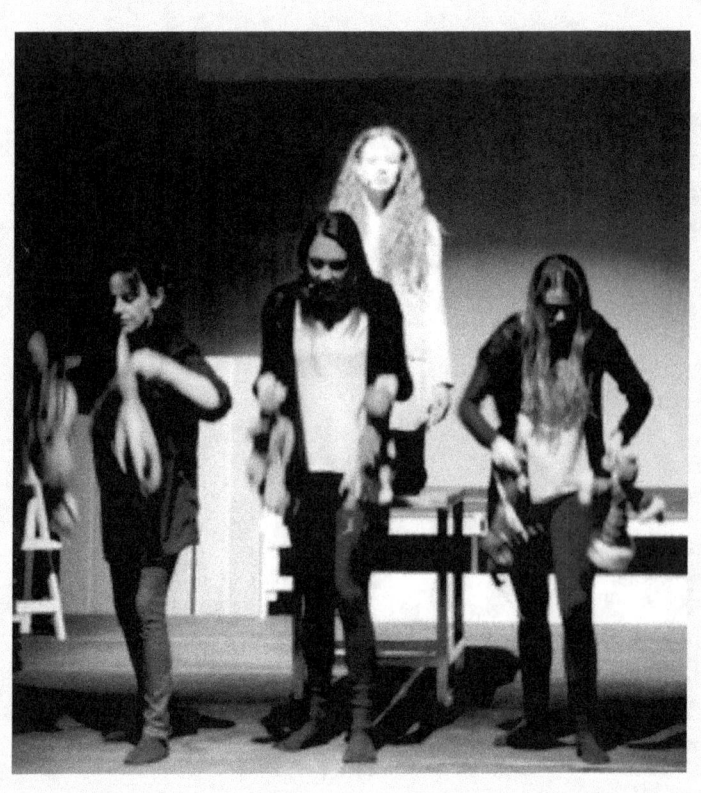

THE WILD HUNT AND THE CREATIVE PROCESS

THE WILD HUNT AND THE CREATIVE PROCESS

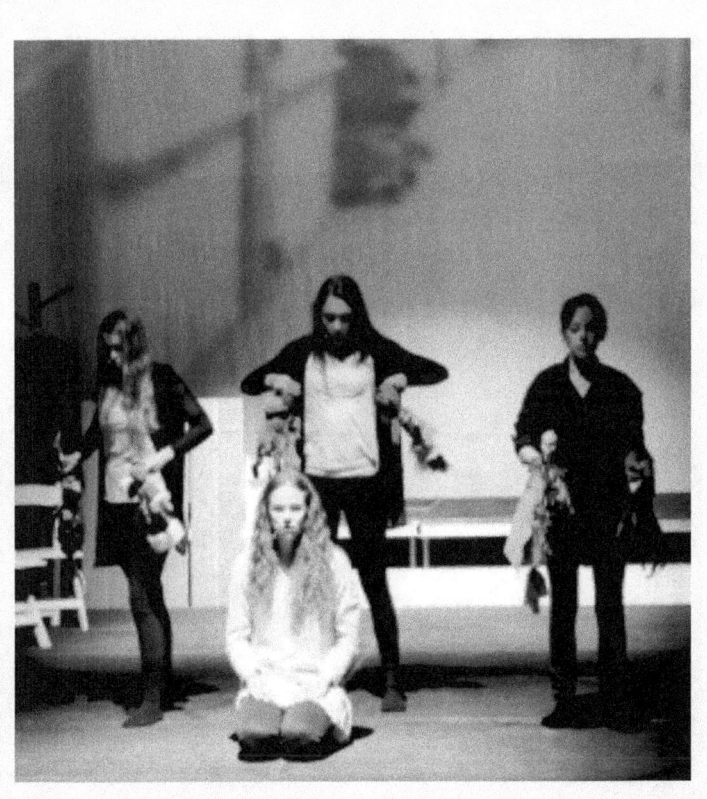

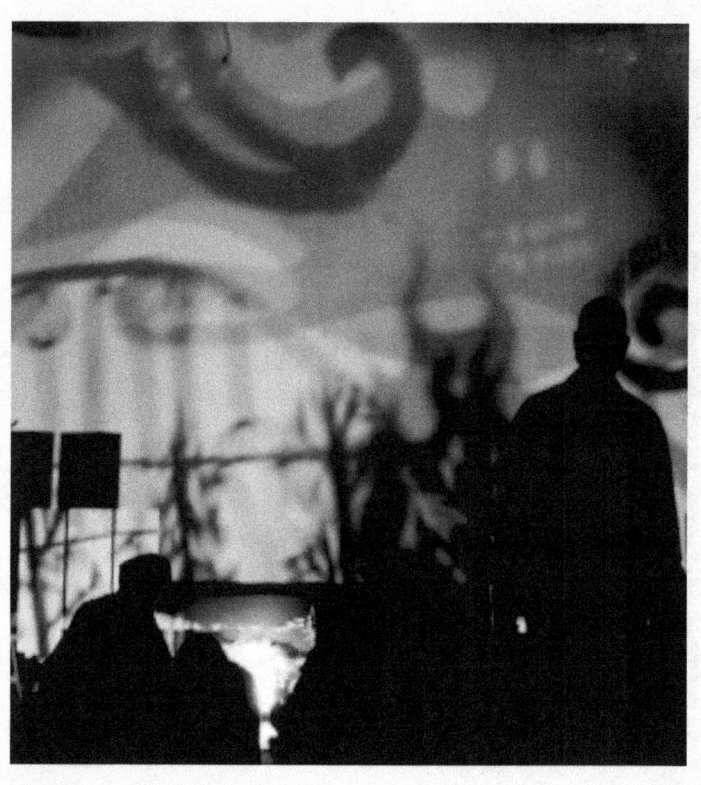

THE WILD HUNT AND THE CREATIVE PROCESS

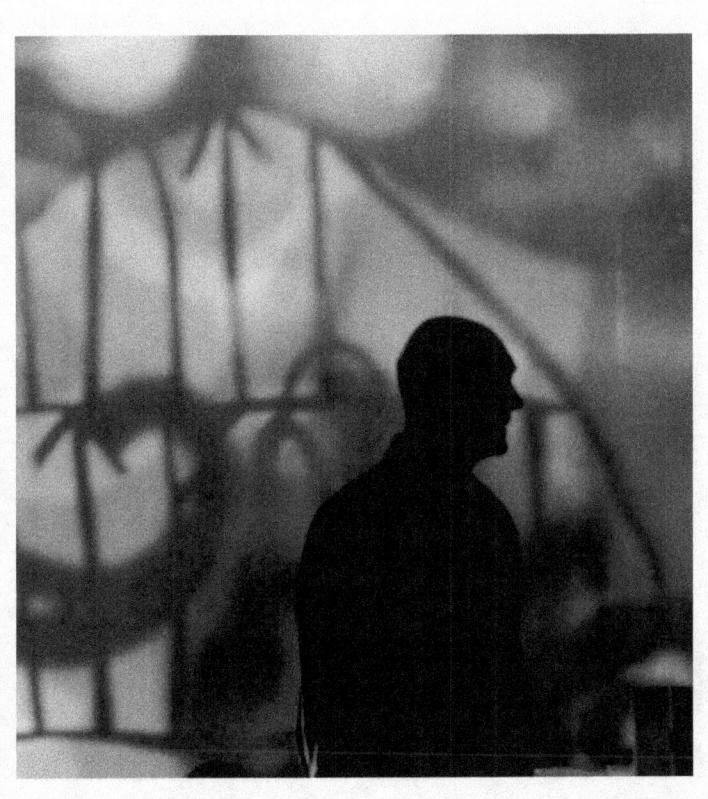

THE WILD HUNT AND THE CREATIVE PROCESS

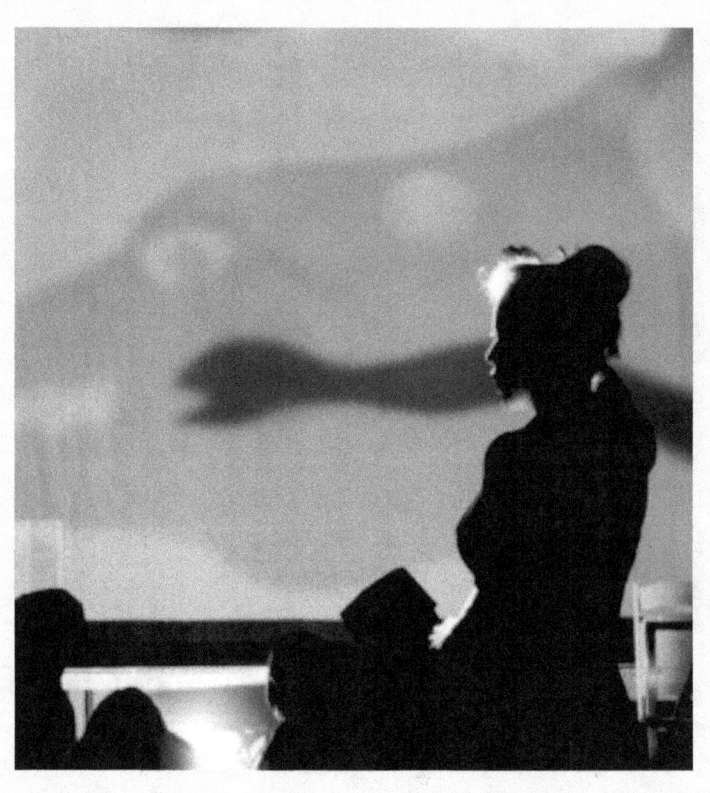

THE WILD HUNT AND THE CREATIVE PROCESS

THE WILD HUNT AND THE CREATIVE PROCESS

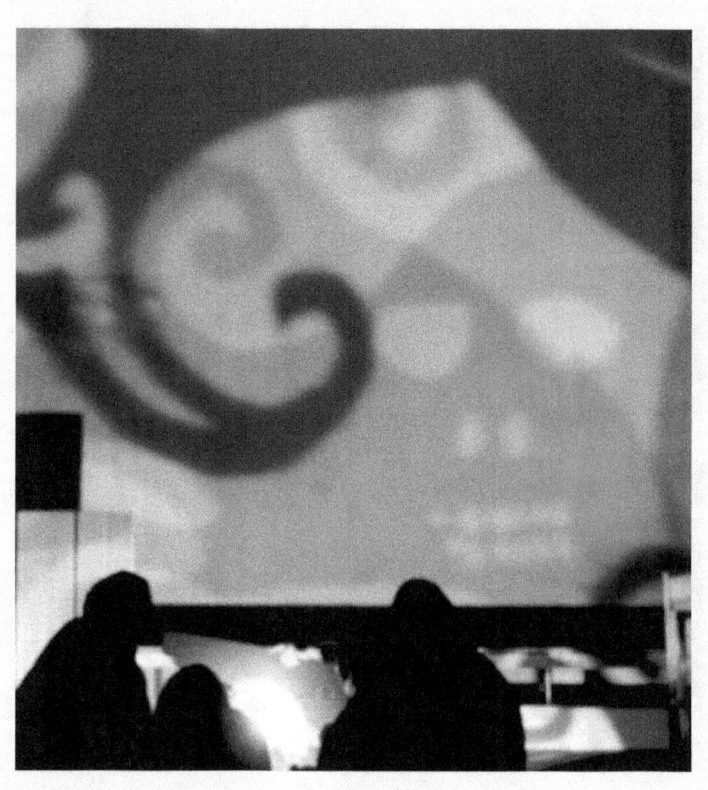

THE WILD HUNT AND THE CREATIVE PROCESS

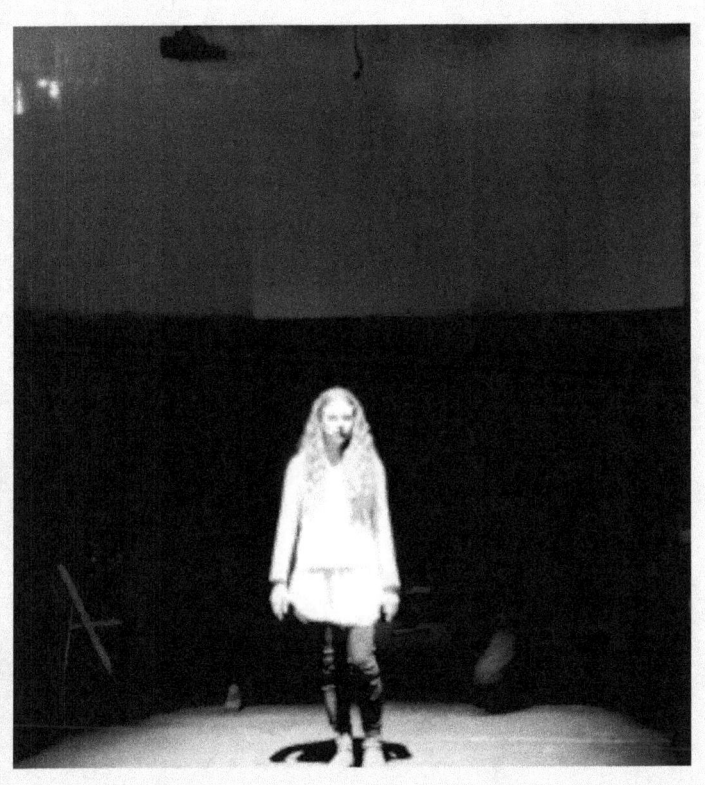

THE WILD HUNT AND THE CREATIVE PROCESS

THE WILD HUNT AND THE CREATIVE PROCESS

THE WILD HUNT AND THE CREATIVE PROCESS

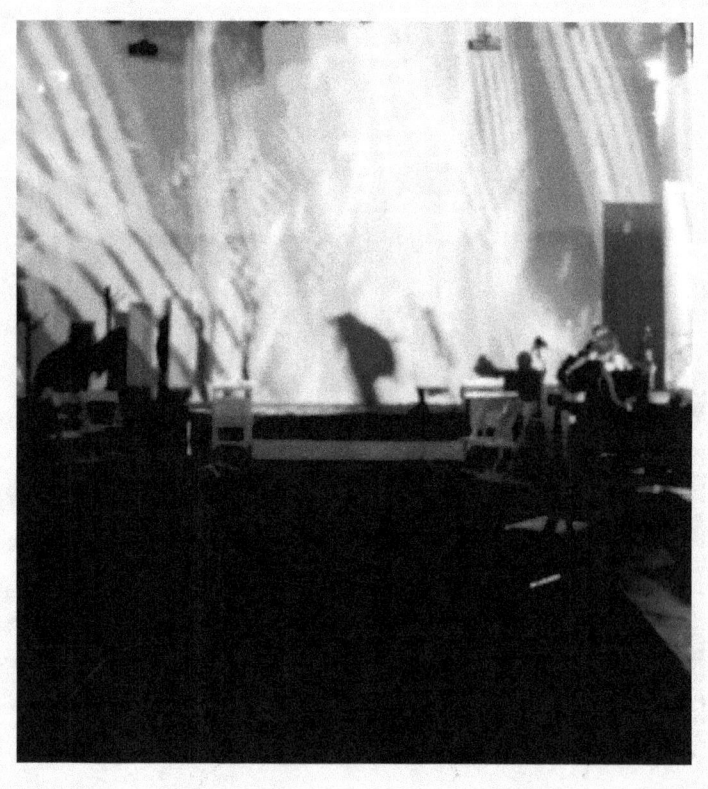

THE WILD HUNT AND THE CREATIVE PROCESS

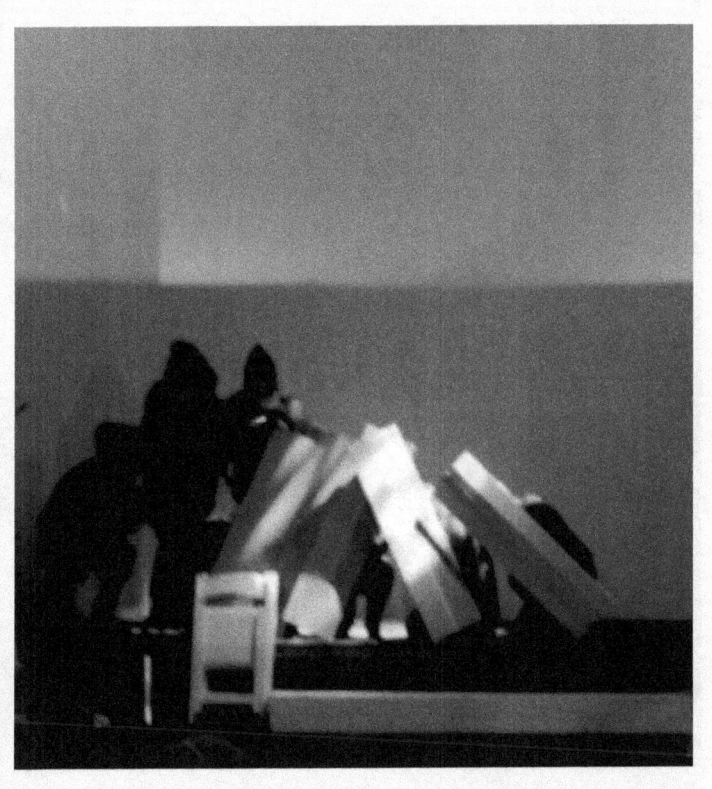

THE WILD HUNT AND THE CREATIVE PROCESS

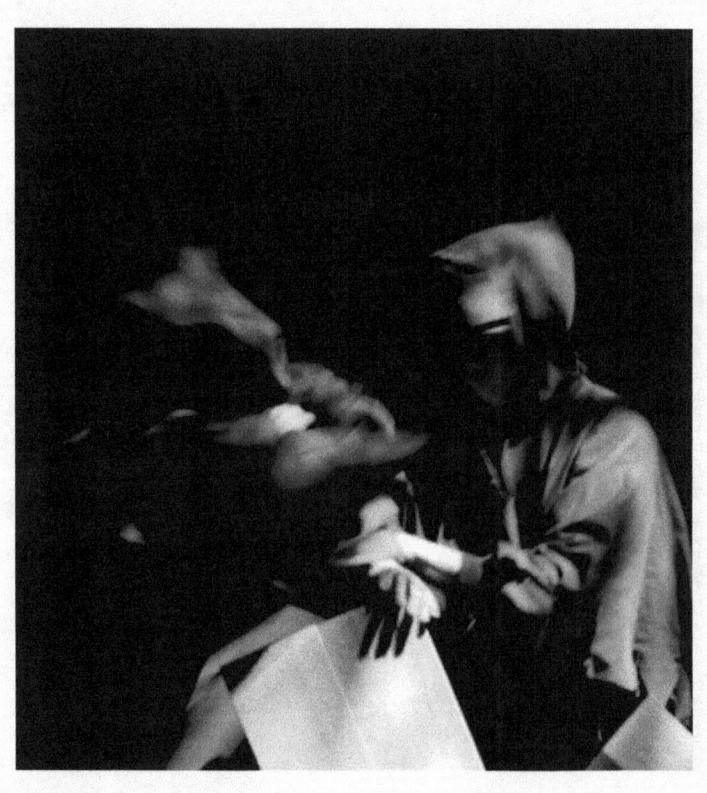

THE WILD HUNT AND THE CREATIVE PROCESS

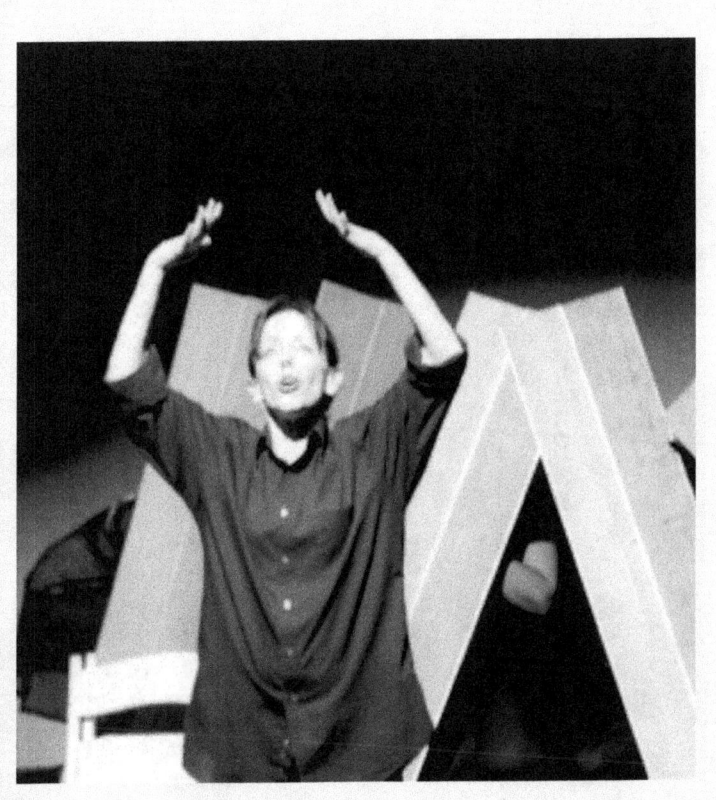

THE WILD HUNT AND THE CREATIVE PROCESS

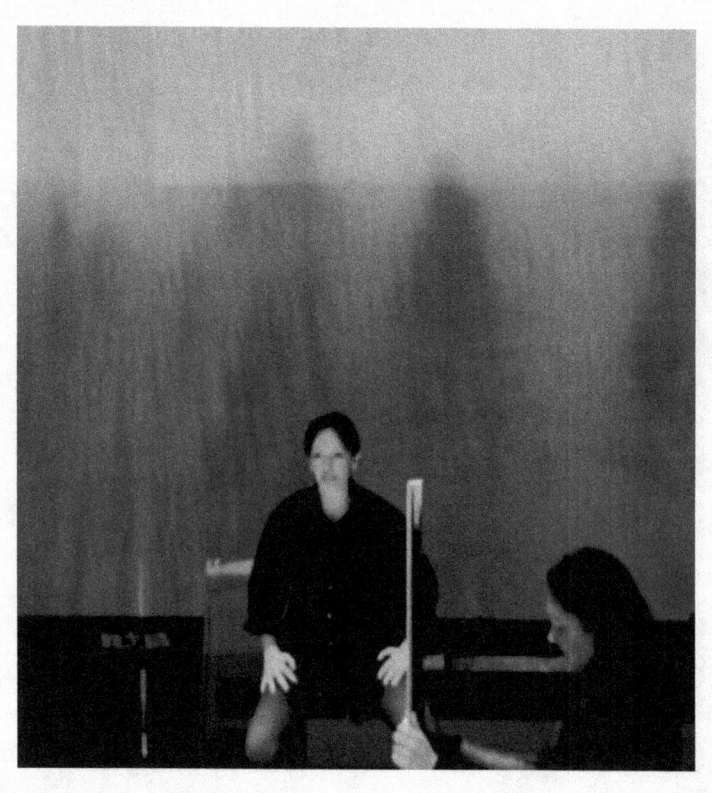

THE WILD HUNT AND THE CREATIVE PROCESS

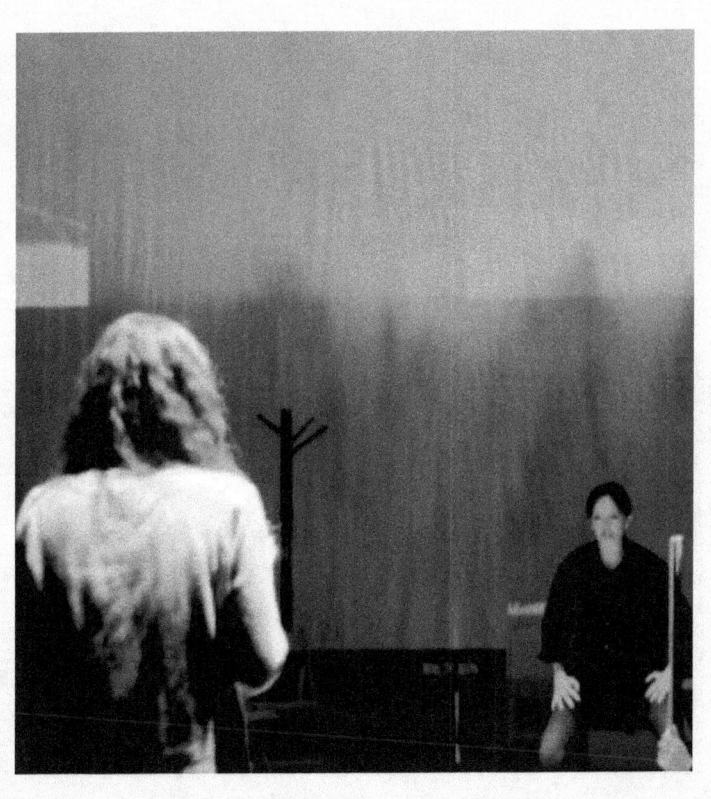

THE WILD HUNT AND THE CREATIVE PROCESS

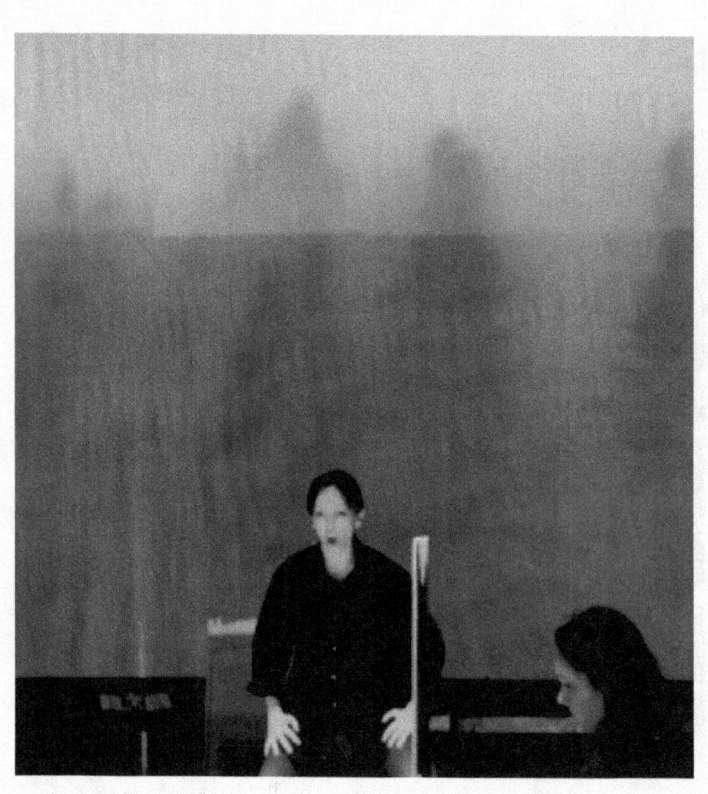

THE WILD HUNT AND THE CREATIVE PROCESS

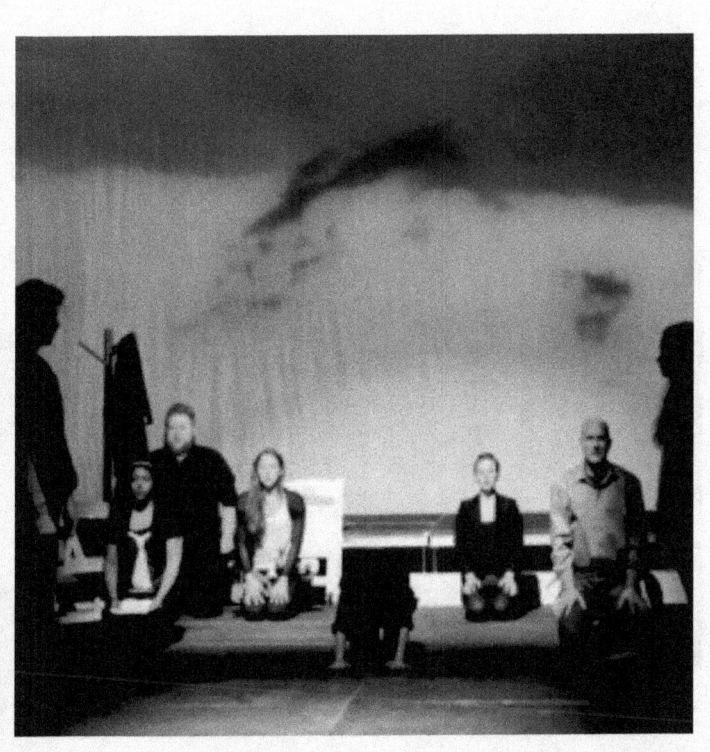

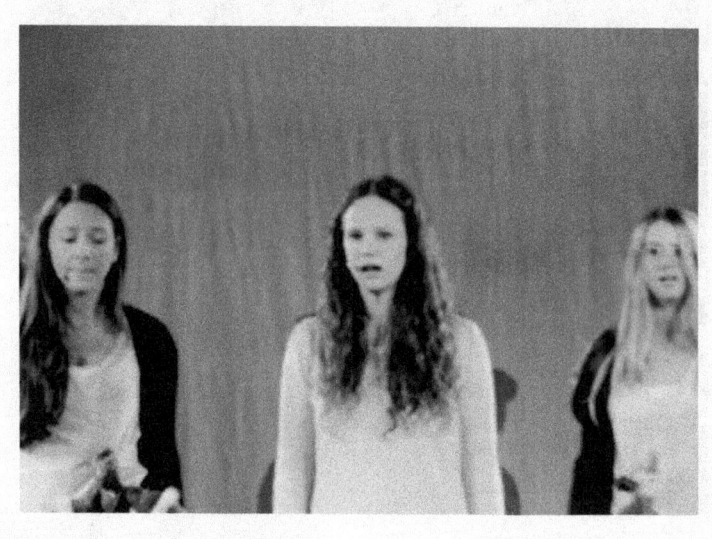

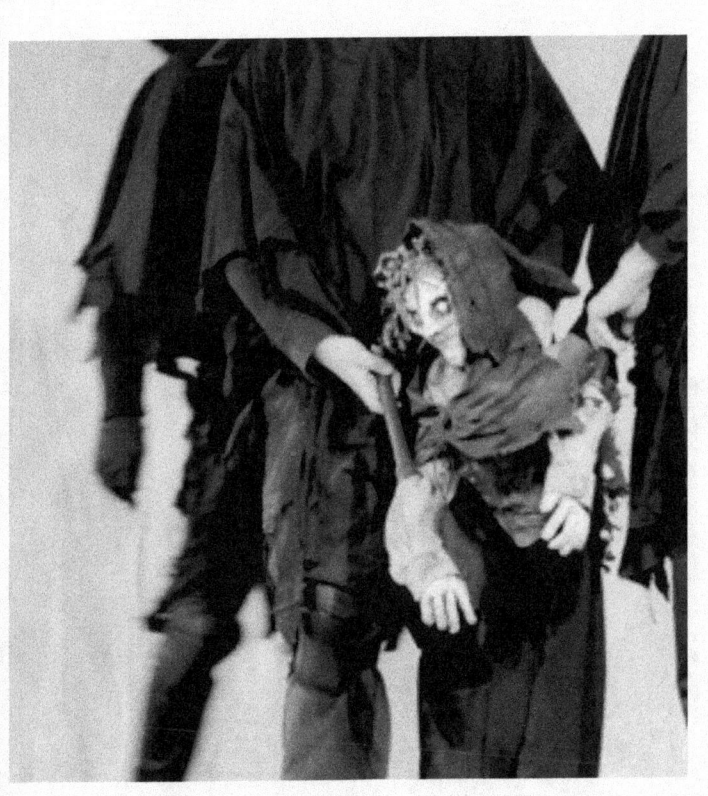

THE WILD HUNT AND THE CREATIVE PROCESS

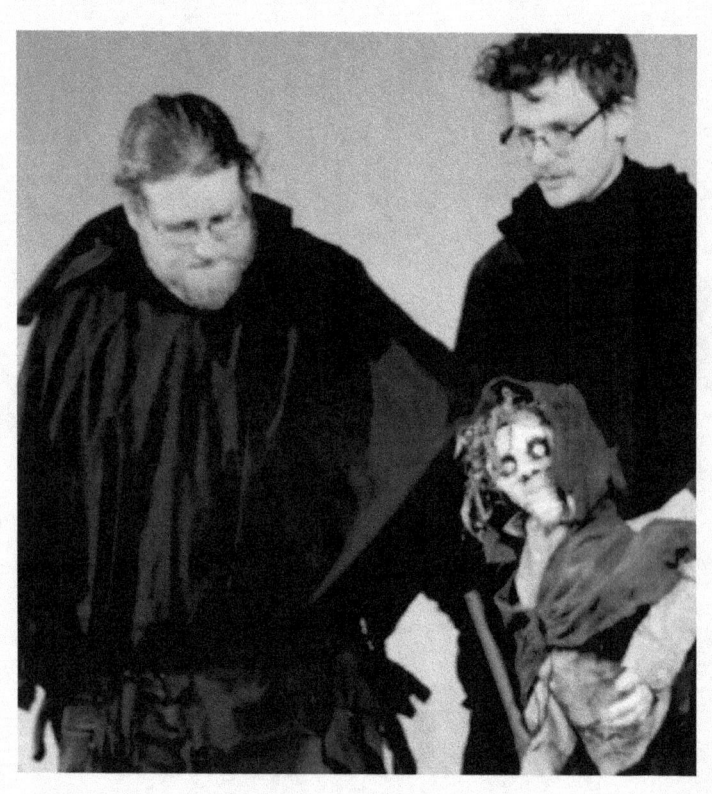

THE WILD HUNT AND THE CREATIVE PROCESS

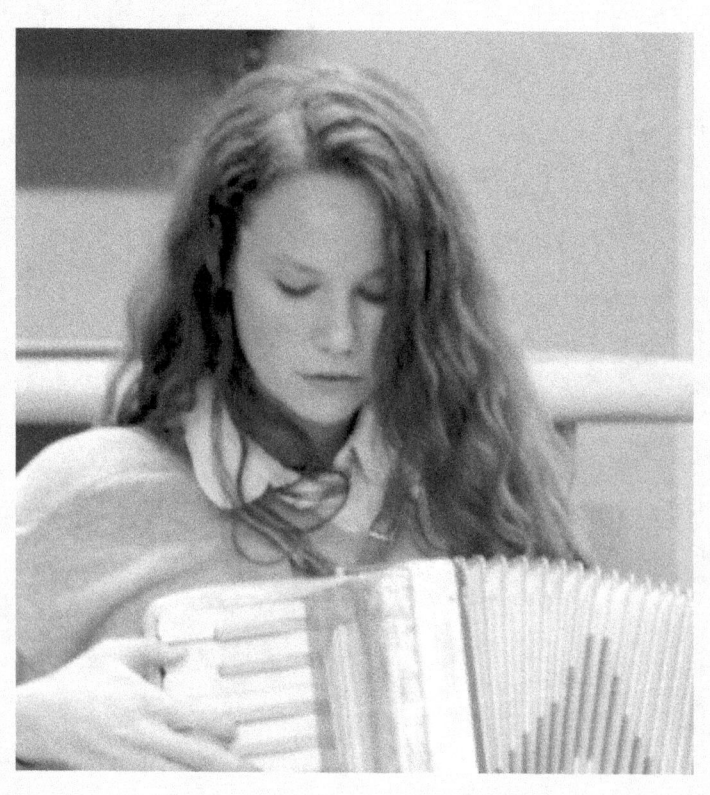

THE WILD HUNT AND THE CREATIVE PROCESS

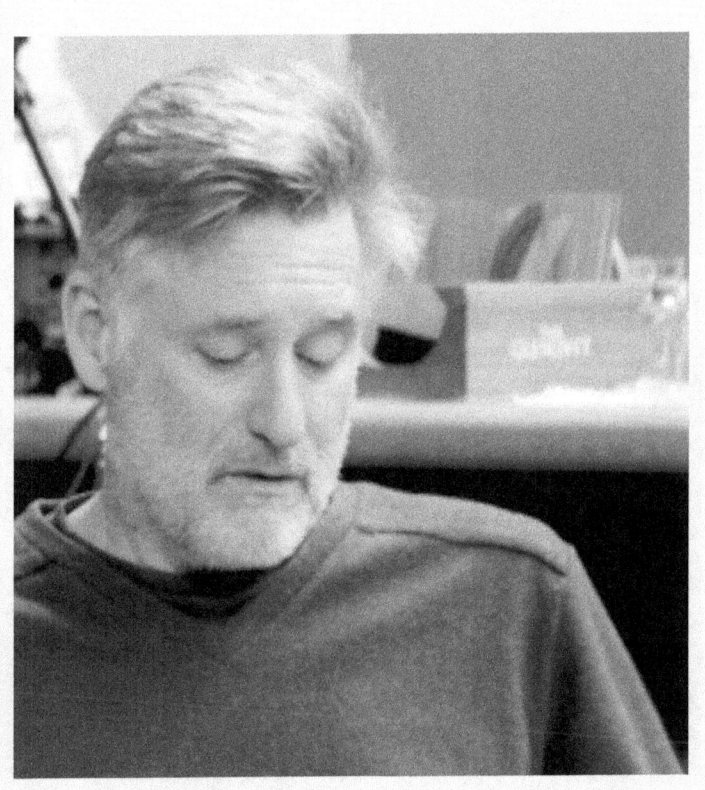

THE WILD HUNT AND THE CREATIVE PROCESS

THE WILD HUNT AND THE CREATIVE PROCESS

THE WILD HUNT AND THE CREATIVE PROCESS

THE WILD HUNT AND THE CREATIVE PROCESS

THE WILD HUNT AND THE CREATIVE PROCESS

THE WILD HUNT AND THE CREATIVE PROCESS

THE WILD HUNT AND THE CREATIVE PROCESS

THE WILD HUNT AND THE CREATIVE PROCESS

THE WILD HUNT AND THE CREATIVE PROCESS

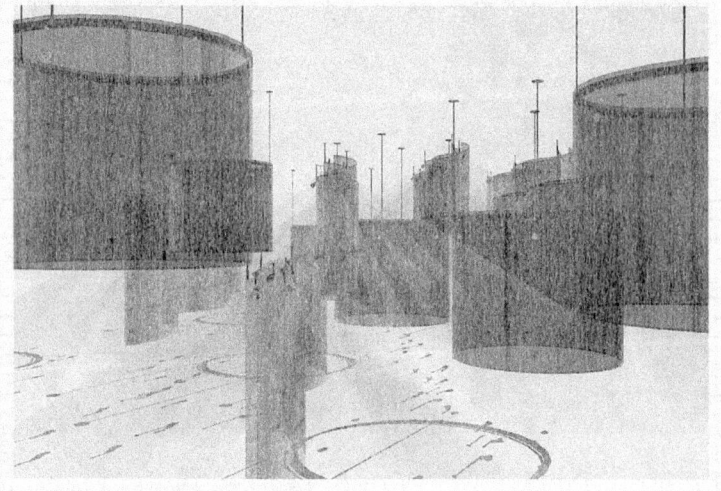

THE WILD HUNT AND THE CREATIVE PROCESS

Myth making. Phillip Baldwin

The mythic making is simple: it spreads out for you as a contingency/
necessity of the day you have to do what you have to do. This might be
banal ritual, or it might be an exciting unknown. Or it might be a sickness
onto death. It is in between your 'necessary spaces' of use and exchange
as a time of reflection. It is entrenched in the present, not usually the
future. It is not usually where all the rest have to watch the grass grow as
evidence of their obedient bean counting toward 'exchange'. It is useful in
a radical present. It is like the pagan pantheism where every object in the
woods is divine, though it is attached to the present divine. It is not, or it
reacts to, the 'bottom-feeder banal' and brutality your fellow ambitious
respond to your grace, energy and necessity. It is in opposition to the
brutality and bullying of the tribe. It helps you through the snide and
savage from those fellow peasants who do not understand that the divine
is in the process specifically. They wait implicitly for the product of their
death and wonder why they have alienated others with their selfishness
and gracelessness. You do not abuse the helpers in the jungle. You share
with them and make them travel colleagues. This is the essence of the
stag and hare hunting game structure. You win with grace. Process. The
mythic making is very simple: it is a bulwark against oblivion.

The mythic making as a bulwark against oblivion is fortified by friends,
enemies, (especially bottom feeding enemies), relations, to doing do not
care, persons that roll off like ticker-tape beneath her social media.
Meanwhile we have grotesque oligarchs telling us to bootstrap, or watch-
out for the lazy with their handouts. The mythic making portends to a jag,
a shift to the liminal within the time/space of process not capitalistic
product. It is a shift, between worlds holding the base value of human
worth, which is infinite in itself, and that which would transport it to the
next level. that's saying the most to say that the Homo sapiens has not
changed in a quarter of a million years. we know how much he lives for
on an average of 4 million years like the rest of the mammals. This is yet
to come. She has been successful. This is that thing which will transform
the beasts, the self castigating beast of all to all now in the sprawling,
dirty, ant-heaps for apes. Fortunately we are like the bonobo lovemaking:
humping for conflict resolution, yet conflict resolution with missiles. It was
a sage, Carl Sagan who said: 'why don't we know any other intelligent
beings in this universe?' His presupposition was that as soon as they
discovered radio waves they discovered radioactive waves. They
discovered the capacity to self annihilate. With the bomb. Is this the
yardstick of the

universe? Smart equals self-destruction? Like a virus it grows short of killing the host. The 6th big extinction is on us. Will 24 thousand survive the way they did with the last extinction. Rats, crows, seagulls, and other hardy animals survive. Those smart enough to transcend 'the tool' transcend the selves obsolescence? I think most of this could be pushed up the table in terms of use value: what is truly useful in new technology (the hand ax of the Homo Erectus was useful and beautiful to them) yet that which is the species undoing is created by technology? We shall see. Or we shall not see in other intelligent beings who self-destructed.

So if this universe is that big, if those many conditions exist for the carbon water-based individuals, then we should know that they could exist. They could be out there. Would we want to meet them know how the animal hates 'difference'? We do know that they could exist. Where are they? Where are the intelligent beings roughly equal to us, who could perhaps save us from us? Or wipe us out. The mythic making, that of the double that of the super double could be trouble beyond our comprehension. It is That of the extra double or the extra shadow double double within. This is myth-making too. It is That of the extra somatic technology that no longer exists in our corporeal memory but in computers. It is a mirror double on the verge of AI to 'invest it with life'. Sentient life. It is that which exists outside the body. Now like memory. Maybe this is why the young love their 'Snap-chat' that erases the gesture seconds after it is made. It is That which should pity the alienation felt by the self-conscious need for Bonobo peace, yet have contempt for it because it got itself into such a situation. Will 'lifeboat violence' get us out? Do we need to kill off billions as the natural phenomena of WW2 did? That which is teetering on a conflict between the sexes, the races, the classes, the generations, and everything that could be brought into tension with the lifeboat numbers of survival. it teeters on an absolute moment to moment annihilation. Myth-making and not religion (this is where the Sikh taxi driver said is pure spirituality) places us in the empathetic moment to decide. To keep our humanity away from the bottom feeding bureaucrats who are efficient at packing people into locked box cars with IBM punch cards. The peacock feathers for the beast can never be so broad as to assuage its innermost self-destructive impulses. So we shall feel that it wants to self-destruct, yet it doesn't. This is empathetic hope in the moment. This is myth-making. This is ascendency over the brutal bottom feeders.

THE WILD HUNT AND THE CREATIVE PROCESS

The beast needs, the beast surrounds the campfire projecting a type of shadow show to the other beasts bent on killing it. Shadows grow and ebb and the 'big man' stays awake and puts another log on the fire for the tribe. How different it is now with CEOs. We need to assuage in the vile export of chance of future demise to retain grace. To think of an alternative to killing off billions ourselves. To live in the myth of the hero. Billions of heroes. We need to think of the beasts soon to overcome this fragile fragile Mal-conceived being. Myth-making makes the story before the person, makes the survival before the fact of banal surviving. It leaves empathetic story in its wake. It Makes the story yet to hear like Scheherazade. It Makes the incantation of base, boring morality something to anger the younger generation's to do something empathetic and beautiful. To use 'useful' technology heroically. It is this that keeps that going. That is that. That is that thing that would like to sleep but can't. That is that thing that self castigate's and diminishes when it needs to turn waking, without medication, into a heroic adventure. Daily. That is that thing which is prideful and arrogant, and ultimately as fragile as glass. This is the humanism of the moment that needs to be taught.

This is myth-making as glass: you can see right through it to the core which perhaps might be empty, perhaps it might not even 'be', but shatter it as a complex Gordian knot and you are just as well with shards. The AI of the financial markets can be controlled from the masses. They fuel it. There it will reflect anything heroic. It will keep us from slaughtering billions. It is an adventure to create the empathetic mythic.

See how the light reflects in shards.

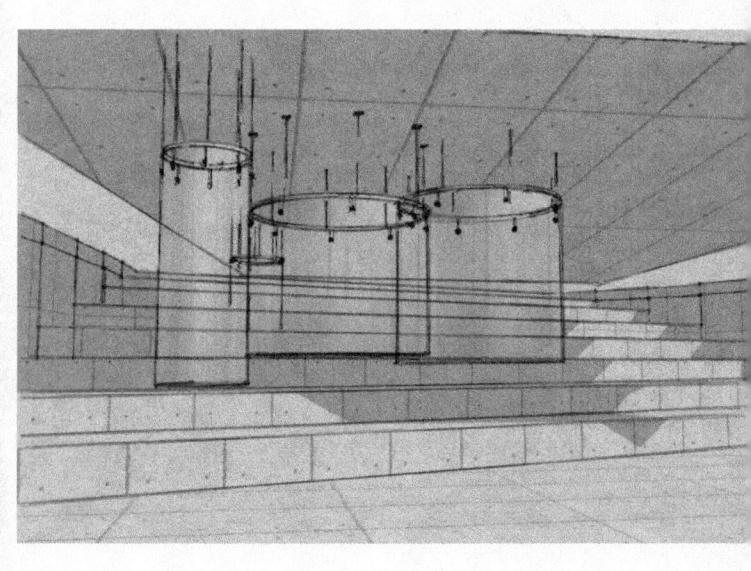

THE WILD HUNT AND THE CREATIVE PROCESS

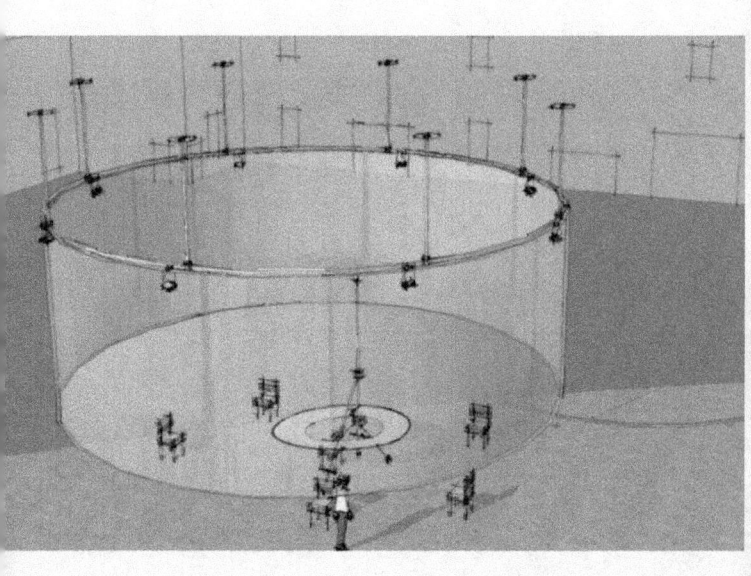

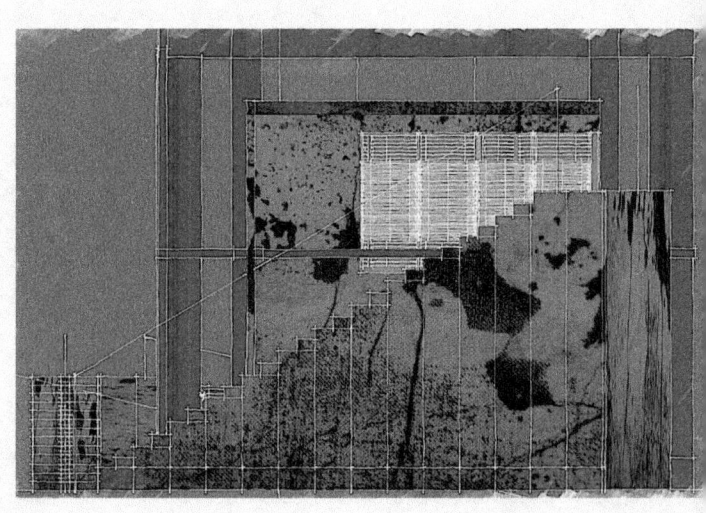

THE WILD HUNT AND THE CREATIVE PROCESS

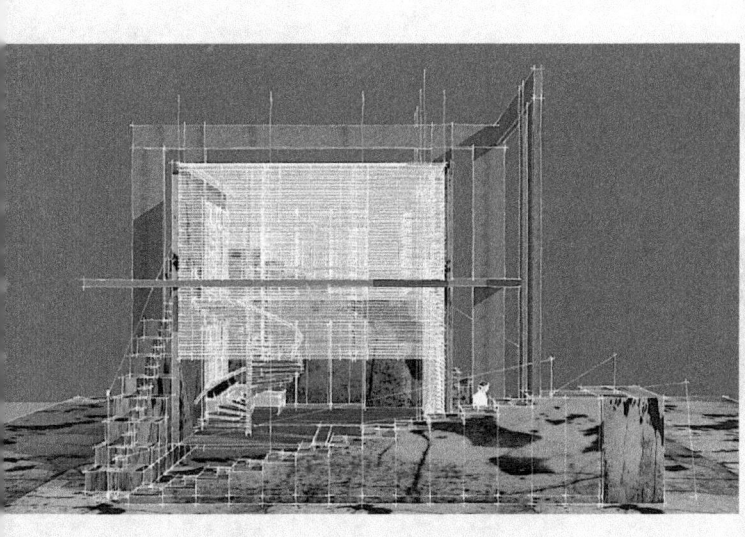

THE WILD HUNT AND THE CREATIVE PROCESS

CREATIVE TECHNOLOGY

THE WILD HUNT AND THE CREATIVE PROCESS

Developing a trans-cultural curriculum with the M-learning touchpad

The fun part is that we have these gadgets now. In the middle of a dinner conversation the film series '7-up' came up. I was sitting in an expensive museum restaurant in Boston and the members at the meal where all in their forties or above. I don't know how the conversation strayed into this subject…perhaps they were talking about the difference between generations…and there we were with most of the members having seen at least one of the four movies. The whole project…began in the sixties by the director (which we were fighting to remember), took a cross section of working class and upper class kids and started their documentary narrative at seven. Seven years old…and I forgot if this was a Rousseau quote…was an age at which a child was supposed to have most of its personality formed. I had read somewhere in my deep past that it took seven years to slough off all of the cells of your body in a complete cycle. In this brief intersection in topics, which were partially clouded by the fog of half-remembered half-truths, none of us could remember the name of the film director.

I had all of my tricks that I had used in my youth to store facts away: random and almost surreal filing systems based on chains of association; cramming factoids and memes away with a slam in a tight and unrelated space; or just relying on a swift and intuitive calling up of facts that had always seemed to be a skill of mine. Before I could call up 'Michael Apted' dredged from knowledge of his fictional films and some past articles I had read about him one of the older members of the party had typed in a Google inquiry on the film and had the name of the director. Satisfied. The search had slightly beat me as the nagging had caused one of the members to cast pull out his iPhone and break the flow of the meal with reliance on gray matter alone. The question, the means, and the answer is particularly ironic in that the premise of the film and the success of the series of visits every seven years had much to do with intrinsic (perhaps the skill in memory and computation had much to do with this) and extrinsic answers. One of the kids in the series (I forget if he was a working class kid) became mentally ill and homeless in his late twenties visit by Apted. It is interesting that Rousseau wrote with pen and paper on this subject I 'Emile', and Apted used the relatively new medium of film on roughly the same subject. What would the ethnographers/ documentarist use in the future? I can imagine a time in the future where the

same conversation will take place with a younger set and the occasion arises where none of them had bothered to place the difficult meme in its place. Or, perhaps, we will all be walking encyclopedias. The verdict is out.

Context, necessity, result. …In a larger context the member of the party could raise a layered 'augmented reality' touch pad on the same question and get a 'bearing on the answer: put the answer in spatial temporal context. I attended a 'Secret Science Club' Meetup (a new social media site devoted to moving atoms around-bodies-in bit-space and vice versa depending on interest) in a warehouse in a post-industrial corner of Brooklyn last night. It was packed. I couldn't believe that you could still move around a group of people that large to hear a science lecture. I was a little bit touched and proud by my fellow Brooklynites. How did they hear about this? There were at least five to six hundred people in standing room only at the Bell House. Why did they go on a cold weeknight to a dark hipster-turnover industrial area of Gawanus? Why were they interested in power point talk by a young, shaved headed Astro-physicist from NYU? Did they pay him? The lecture was on what came before the big bang and what is 'dark matter'? The lecture was jovial, accessible, dealt with the big philosophical issues, and the Q and A was stunning: the audience knew their shit also. A couple of 'Suits' came into the event and my companion said 'He is here to OCCUPY hipsters'.

My immediate point is…to make the context of a lifelong learning salient…is to have the burning curiosity to load, unlock, fire. In the geo-positioning of the expensive lunch the flow of the subject was engaging and slightly competitive. In a dark, cold warehouse district the context of the talk perhaps augmented the quality of the talk. The quality of the audience who made the pilgrimage on the R train was amazing. Can we get this same cognitive learning salience by holding up an augmented reality pad anywhere, anytime? Or is it best when we are at our expensive 'study abroad' program in Florence where we question why we are even paying for brick and mortar? Why return to a drab and pompous campus? Why don't we always meet in post-industrial salons anywhere on earth and sip a Pabst Blue Ribbon at the same time?

THE WILD HUNT AND THE CREATIVE PROCESS

Here is the immediate take on this: you need to create and infuse salience into the flow of the context-less 'classroom without walls'. How is that done? I have chosen Howard Gardeners eight 'intelligences' to explore to diversify the web of the transcultural and trans-subjective curriculum. I have also presented this so that a level of creativity and innovation will be seen across the curriculum.

LOGICAL-MATHEMATICAL:

This subject is as difficult and disciplined as it is pervasive and necessary. Within a highly technocratic culture the facility with numbers is an imperative. Where is the best place to practice this? To gain and rehearse competency? How can we not just have 'the answers' remain inert and predigested in a book but have a 'real life' application without making ten year olds engineers to bridges that would fall down. Weaving these problems into game structures is one proposal.

LINGUISTIC-VERBAL:

It is important to absorb the legacy of a culture through its literature. But the technology of writing is only one medium...perhaps this is the point of Socrates who never wrote anything down and preferred each context, discourse, imperative and salience to take place with a question and proofs which manifested themselves like some Geometric exercise. Learning other languages, expressions, and 'logics' through linguistic means is extremely important. If the touch pad is held up this can be created with a 360-degree orientation.

INTER-PERSONAL:

The ability and facility with social interaction is a parents sleepless concern for their child. When a child is troubled by Autism, Aspergers, or some sort of social inability the disconnect with society magnifies to tragic proportions. Would a M-learning device enhance or exacerbate the conditions of sociability?

BODILY-KINESTHETIC:

Many are worried that the interface with machines will lead to a lost of the exercised body. It has and it still does. The M-learning platforms would, at least in theory, place the individual 'outside' in the greater world of learning.... perhaps walking.

NATURALIST:
The facts and perceptions of the natural world are complex. The M-learning platform is an easy way to take learning 'filter' to the perception of the interrelated ecologies.

VISUAL SPATIAL:
The use of visual culture is on the front line of the E-learning and now M-learning platforms. This will continue.

INTRA-PERSONAL:
It is debatable that a gadget will enhance a means of greater self-understanding. 'Auto-telic' (or self discovery as an ends) methods, perhaps, are archived by 'turning off'.

MUSICAL:
How can we really listen without the surround sound becoming noise? What is ambience and what is salience? The means of discovering this are vast and technically adept.
This is a beginning to a means of 'parsing out' of a M-learning curriculum for the DIY Future.

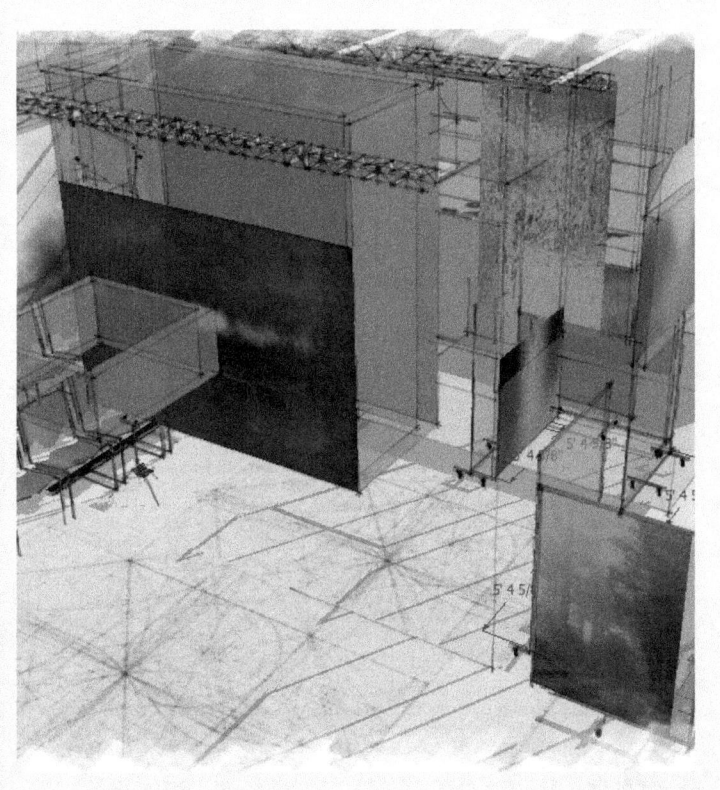

THE WILD HUNT AND THE CREATIVE PROCESS

The future of the audience.

"The final poem will be the poem of fact in the language of fact. But it will be the poem
of fact not realized before."
WALLACE STEVENS

I have just spent twelve weeks going over models for the interpretation of the play. In this class of play analysis we have covered formalism, race, class, and gender models of the analysis of the script and the conjectured performance within a chronological epoch. We have explored the relationship of the stage illusion to mythic and religious frameworks and examined the capacity of the stage illusion to 'mirror' dominate social and psychological aspects of a particular society, historical time, and formal innovations in the molding of a play and a script. There are many different models that we could follow for this endeavor.... the formal structures and adopted models of 'the reality' of the play as interesting as the plays itself. What I think is a neglected topic through the history of the play analysis...script and spectacle analysis also...it a study of the audience. With this approach...and especially on the heels of the current use of mobile media within audiences and classes, I wish to study the aspects of the new audience as some of the most challenging new aspects of presenting a spectacle today. I wish to examine the dynamics of the audience from a particular Lacanian aspect of their resulting 'otherness' to that of the fabricated spectacle.

The future of the audience must retain some...even a sliver...of faith in the message communicated. As this century still alternates between celebrity and connectivity the privileged position of the emitter has waned. Celebrity (or power) will create its necessary message for the social body...how to sacrifice, how to behave, how to run up debt, how to fight wars, how to procreate and determine your sexuality...and then the emitter will expect to 'push' this message of an implied behavior across some magical, clear, hypodermic needle to every member of the society who has hooked up to the need for connectivity with the ubiquitous tools of the society. For the Greeks this was going to the large theaters to see the celebrity playwright perform a work implicitly supporting or criticizing some political or military champagne. With world war two the well-orchestrated staging of Pearl Harbor resulted in the creation of meaning that enticed the male population to war. One could say we should understand the basic socio economics behind a society and then we would understand what the implicit imports that this 'hypodermic needle' would have within a society. Yet when and intended 'big staged spectacle' happens there is an immediate attack by the media producing population for connectivity. Rather than corroding the original meaning that the corporate produced spectacle had implied this new connectivity would serve to fracture it into tinier bits that then get pushed across the Internet searching for salience. As celebrity had once been that feature of a fetishistic and almost polytheistic society (each touch or closeness with celebrity gave the owner a bracing against death and alienation) one of the core meanings of consolidating agency around corporate celebrity is this denial of death and decay.

John Wayne showed up in the hospital of the marines wounded in Iwo Jima in a cowboy suit (he didn't fight in any theater of operation unlike other Hollywood stars) and he was booed and jeered. Once the marines had experienced the true violent message behind warfare they had this rare opportunity to 'send back' their opinion and perspective at the essence of this engagement. This same scene in the era of twitter and face book would send the parody out to the general public in an immediate connectivity to show the intention of propaganda in war production. We...or they, the young men.... would then have a 'heads up' as to why they should fight and where should they move if they find themselves in harms way. This level of 'backflow' was already in operation during the Vietnam War when the proliferation of unedited images of death and carnage came in to the American public through the

television. The hypodermic needle was taking on a new aspect. But where would that where be in an interlinked world? There were draft dodgers in the Second World War but the choice of moving to Mexico or some other far off neutral place would just alienate the agent from the 'big actions' of his society. E mail and other telematic means would reverse that alienation but the 'heads up' feature of connectivity…presenting many other perspective in an otherwise trapped situation…. caused by government and dominate shareholders. At beginning of the seventies there were an average 500 defections per week by American soldiers. Do we hear about any of these things with the current two wars?

Nick Rosen traveled the country and examined some of these people who were living 'off grid' in the American landscape. For the most part he painted a picture of a destitute people with occasional examples of those who had found a higher alternative lifestyle. Some of the arguments from the survivalists he interviewed went this way: the American currency is based on the dynamics of continual growth for jobs and for payments and entitlements that need to be paid back. There is no gold or other capital to back up the currency. With the approach of peak oil all aspects of growth are in question and nowhere is the government or 'captains of industry' preparing for a sustainable development. It is because of this reason of the necessity of growth and the need to secure new, cheap oil that the idea of taking over oil fiends of other sovereign nations needed to be put into place. To fight a war you need popular support. To do this you need to present a spectacle on a large global scale. For this the events of 911 were staged and executed in the public. The events of this staged spectacle we carried out and this could lead to the 'justified' war with Iraq, the second biggest producer of oil.

Simple hypodermic in the realm of connectivity. Theories of cranks in the woods? Perhaps. Perhaps it is too simple to be plausible. Yet, perhaps, the need to move to a sustainable economy is that thing now impossible to do.

Sent from my iPad

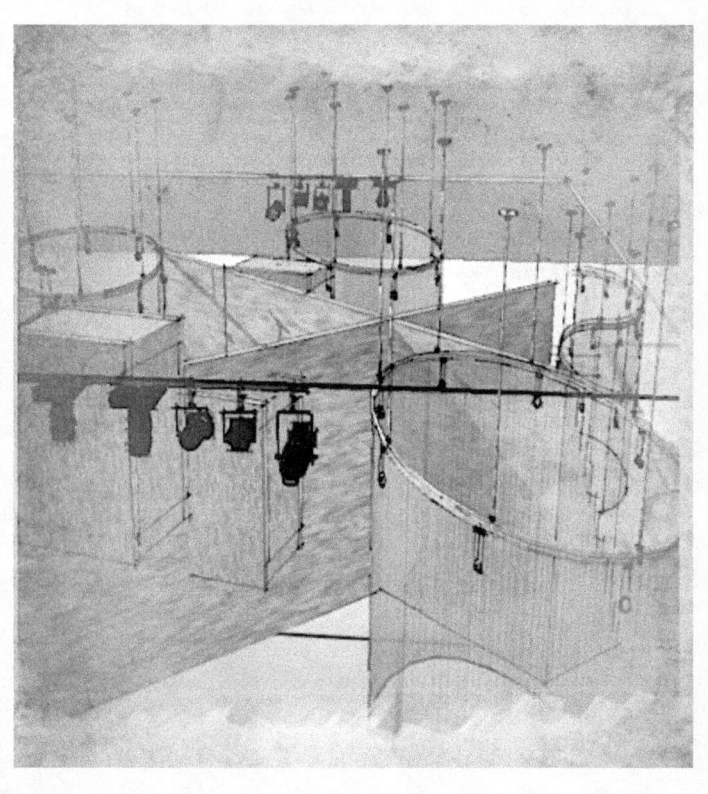

THE WILD HUNT AND THE CREATIVE PROCESS

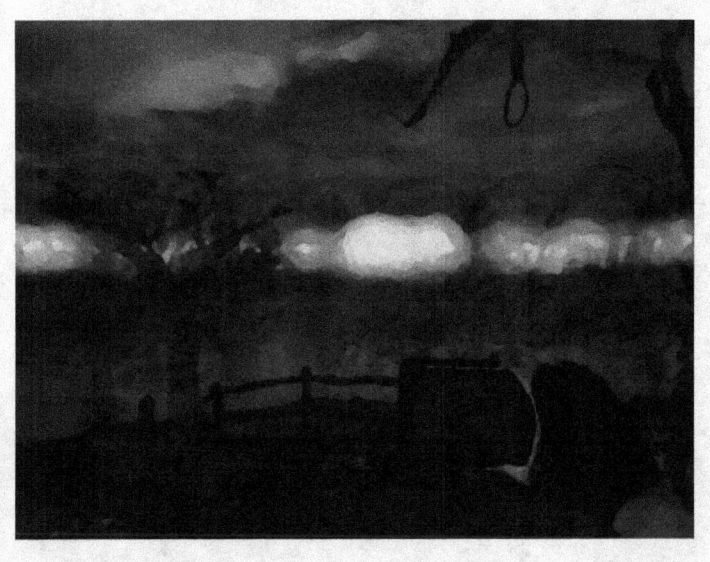

THE WILD HUNT AND THE CREATIVE PROCESS

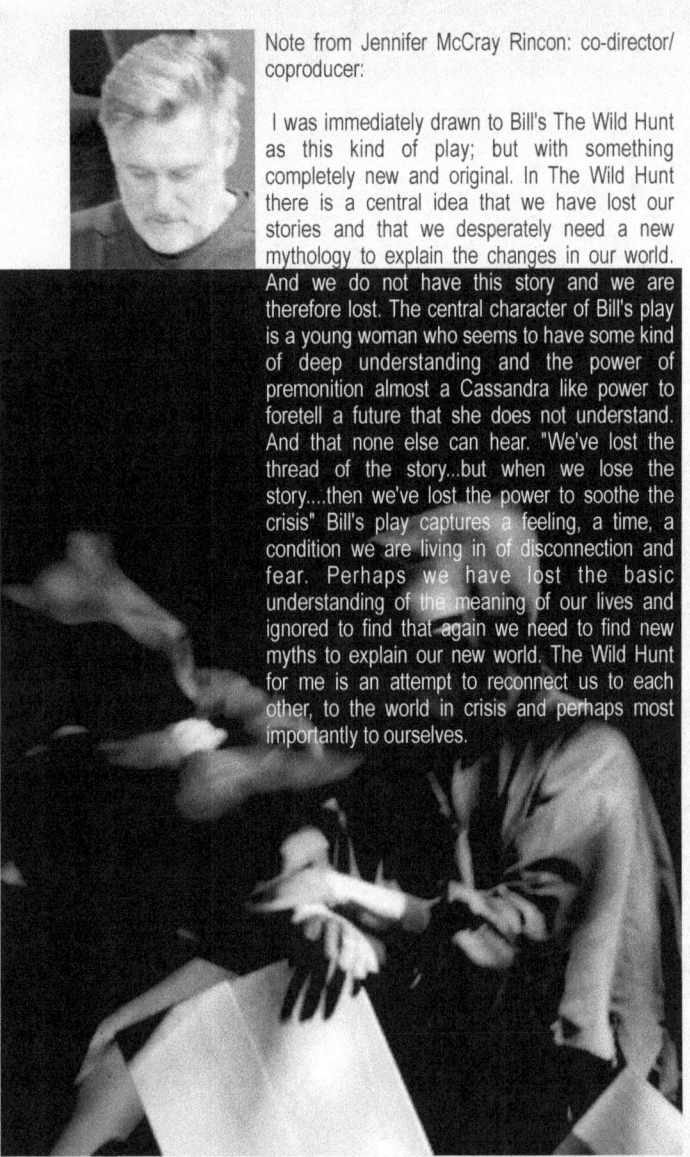

Note from Jennifer McCray Rincon: co-director/coproducer:

I was immediately drawn to Bill's The Wild Hunt as this kind of play; but with something completely new and original. In The Wild Hunt there is a central idea that we have lost our stories and that we desperately need a new mythology to explain the changes in our world. And we do not have this story and we are therefore lost. The central character of Bill's play is a young woman who seems to have some kind of deep understanding and the power of premonition almost a Cassandra like power to foretell a future that she does not understand. And that none else can hear. "We've lost the thread of the story...but when we lose the story....then we've lost the power to soothe the crisis" Bill's play captures a feeling, a time, a condition we are living in of disconnection and fear. Perhaps we have lost the basic understanding of the meaning of our lives and ignored to find that again we need to find new myths to explain our new world. The Wild Hunt for me is an attempt to reconnect us to each other, to the world in crisis and perhaps most importantly to ourselves.

www.ingramcontent.com/pod-product-compliance
Lightning Source LLC
Chambersburg PA
CBHW060836170526
45158CB00001B/177